THEN *&* NOW

HERSHEY

OPPOSITE: Since the founding of Hershey in 1903, Chocolate Avenue, seen here c. 1920, has served as the town's main street. (Courtesy of Milton Hershey School Collection.)

THEN & NOW

HERSHEY

James D. McMahon Jr.

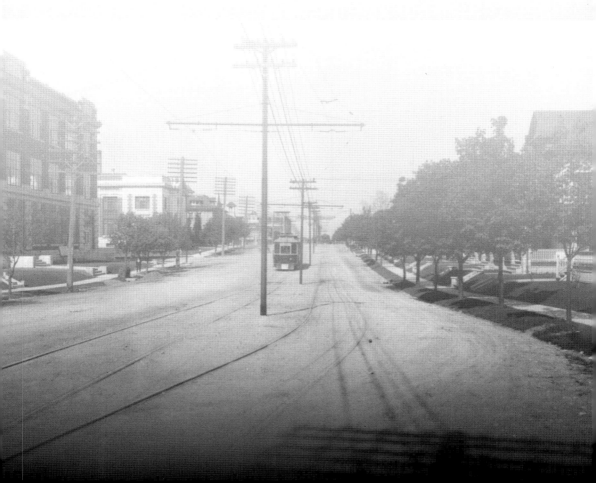

To Milton and Catherine Hershey for their vision and generosity and my wife, Lois Miklas, whose suggestions, guidance, and support kept this project moving forward as I divided my time between family, work, book, and dissertation

Copyright © 2015 by Milton Hershey School®
ISBN 978-1-4671-2331-0

Library of Congress Control Number: 2014952496

Published by Arcadia Publishing
Charleston, South Carolina

Printed in the United States of America

Then and Now is a registered trademark and is used under license from
Salamander Books Limited

For all general information, please contact Arcadia Publishing:
Telephone 843-853-2070
Fax 843-853-0044
E-mail sales@arcadiapublishing.com
For customer service and orders:
Toll-Free 1-888-313-2665

Visit us on the Internet at www.arcadiapublishing.com

ON THE FRONT COVER: Since 1905, the Hershey Volunteer Fire Department Company has provided the town of Hershey and surrounding communities with expert volunteer fire and rescue protection. The department moved from its original location on Chocolate Avenue to its present site on West Caracas Avenue in 1928. (Then image courtesy of Milton Hershey School Collection; now image author's collection.)

ON THE BACK COVER: Milton Hershey broke ground on what would eventually become the largest chocolate factory in the world on March 2, 1903. Constructed of limestone removed from local fields, the first factory buildings covered six acres. Various additions increased the factory's floor space to 18 acres by 1911 and 35 acres by 1915. Eventually, the factory would reach 2.5 million square feet. (Courtesy of Milton Hershey School Collection.)

Contents

ACKNOWLEDGMENTS

Throughout the book, credit to the owner of each photograph has been given. Unless otherwise stated, all "Then" images are courtesy of Milton Hershey School and all "Now" images are from the author's collection.

This book would not have been possible without the help of many organizations and individuals who generously gave of their time and talent to insure that a comprehensive telling of the many stories of Hershey through photographs could be achieved. Beginning with the various Hershey entities, they are, alphabetically:

The Hershey Company—Jeff Beckman, director, corporate communications; Todd Camp, senior director, corporate social responsibility; Lois B. Duquette, associate general counsel; Stephen Hinkle, facilities planner, global technical solutions; Diane R. Kamp, senior paralegal; Brendan Kissane, senior director of cocoa sustainability; Scott Rownd, associate manager, corporate social responsibility; and Joe Wolfe, project coordinator, global technical solutions.

Hershey Entertainment & Resorts Company—Edna Jenkins, manager, legal affairs, senior paralegal; Frank Miles, vice president, secretary, and general counsel; Donald Rhoads Jr., manager, production; and Kimberly Schaller, executive vice president and chief marketing officer.

Hershey Trust Company—Joan Boltz, real estate manager; Carol Danz, senior paralegal; and Linda Vettori, manager, legal affairs and assistant secretary, Milton Hershey School and Hershey Trust Company.

Milton Hershey School—Susan Alger, coordinator, school history; Andrew Cline, vice president, legal affairs and general counsel; John Estey, past interim president; Peter Gurt (class of 1985), president; Sally Purcell, school history assistant; Lisa Scullin, vice president, communications; and Joan Singleton, vice president, human resources.

The M.S. Hershey Foundation—Tammy L. Hamilton, archivist, Hershey Community Archives; Jill Manley, director of communications & public relations, The M.S. Hershey Foundation; Donald Papson, executive director, The M.S. Hershey Foundation; and Pam Whitenack, director, Hershey Community Archives.

Penn State Milton S. Hershey Medical Center and Penn State College of Medicine—Erni Peterson, director, creative services, Penn State College of Medicine; and Sean Young, chief marketing officer, Penn State Milton S. Hershey Medical Center.

All About Hershey, LLC—James George

Media Boomtown, LLC—Edward Fox

The *Sun*—David Buffington, editor, and Nathan Merkel, staff photographer.

Special thanks to Neil Fasnacht for proofreading and fact checking.

Introduction

The story of Hershey begins with the story of Milton S. Hershey (1857–1945), the "Man Behind the Chocolate Bar," an American businessman and philanthropist best known for his creation of the Hershey Chocolate Company and Milton Hershey School, as well as the town that continues to proudly bear his name. As an entrepreneur, Hershey pioneered the mass production of milk chocolate, turning it from a prohibitively expensive European luxury item into a product that almost anyone could afford. Though born in a stone farmhouse just outside of what is now the town of Hershey, Pennsylvania, Milton Hershey spent most of his formative years and experienced his first business success manufacturing caramels in the nearby town of Lancaster. Here, he also met many of the men who would later play influential roles in creating the town, school, and various businesses that would come to make up the model community of Hershey.

In 1903, after deciding to leave Lancaster to concentrate on the manufacture of milk chocolate rather than caramels, Milton Hershey chose a site near his birthplace to begin construction on what was to become the largest chocolate factory in the world. By choosing a rural site for his chocolate factory, Hershey also envisioned building a complete new community. He agreed with his contemporaries who believed as he did that providing a healthy environment for workers made good business sense. Hershey worked hard to see that his town did not look and feel like other planned communities. Homes were built in a variety of conventional yet comfortable styles, and workers were encouraged to own rather than to rent their homes. The main intersecting streets were named Cocoa and Chocolate Avenues, and soon many other streets sprang up with names echoing the places in which cocoa beans were grown, including Areba, Bahia, Caracas, Ceylon, Granada, Java, Para, and Trinidad. During this period, Hershey also established a sugar mill and mill town at Central Hershey in Cuba, which supplied sugar for his chocolate-making operations until the Cuban holdings were sold in 1946.

A number of structures constructed by Milton Hershey through the 1930s, especially public buildings in the downtown center, were removed during a period of urban renewal in the 1960s. While several of these buildings were simply demolished to make way for larger structures, others had indeed outlived their usefulness or become too expensive to renovate. A few structures, such as the Hershey Department Store building, originally constructed as the Hershey Press Building in 1916, managed to survive—covered in a thick sheath of bright gold aluminum siding, waiting for a new century and a new era of appreciation. Others like the Hershey Trust Company bank building and High Point Mansion, the home of Milton Hershey and his wife, Catherine, survived relatively unscathed—at least on the exterior.

During the 1930s, Milton Hershey took advantage of a ready-and-able supply of labor and cheap raw materials to embark upon a massive building campaign that gave the community a number of structures designed to meet a wide range of recreational, cultural, and educational needs, which still benefit the community of Hershey today. Landmarks from this period include the Hershey Community Building and Theatre, The Hotel Hershey, the Windowless Office Building of the Hershey Chocolate

Corporation (now The Hershey Company), the Hershey Sports Arena and Stadium (now Hersheypark Arena and Stadium), and what is now known as Hershey Gardens of The M.S. Hershey Foundation and Catherine Hall of Milton Hershey School. The construction of numerous structures and facilities during this period helped transform Hershey into a nationally known tourist destination—a label even more appropriate today as the town continues to build upon its legacy, redevelop its downtown center, and transform the vision of its founder to meet the demands of the 21st century.

More than a place, Hershey has become a concept synonymous with the sum total of those people, places, products, and institutions that share the Hershey name. An integral part of the Hershey legacy is Milton Hershey School. Unable to have children of their own, Milton and Catherine Hershey decided to use their wealth to create a home and school for children of need. Established on November 15, 1909, the first students of what was then called the Hershey Industrial School lived and attended class in the stone farmhome where Hershey was born. Here, they were provided with a stable home life and a rigorous combination of agricultural, vocational, and academic learning. Today, Milton Hershey School continues the tradition of preparing students to lead productive and fulfilling lives by providing a cost-free, private coeducational home and school for children from families of low income, limited resources, and social need.

Historical photographs and images included in this book are drawn from the archive of Milton Hershey School unless otherwise noted. Contemporary photographs have been taken by the author unless otherwise noted. Images have been selected to chronicle changes to the physical layout of the chocolate factory and town, advertising and product packaging, the town and school for disadvantaged youth, the city of Lancaster where Hershey achieved his first business success and the country of Cuba where he established sugar-making facilities and a second model town in 1916, and Hershey-owned business and philanthropic interests in the town of Hershey. Views have been selected to show the evolution of a particular building or view over time as well as the evolution of a particular process or function over time, providing a visual account to students, staff, and alumni of Milton Hershey School as well as those with a general interest in the Hershey legacy, all built on chocolate.

THE LARGEST CHOCOLATE FACTORY IN THE WORLD

THE HERSHEY CHOCOLATE COMPANY

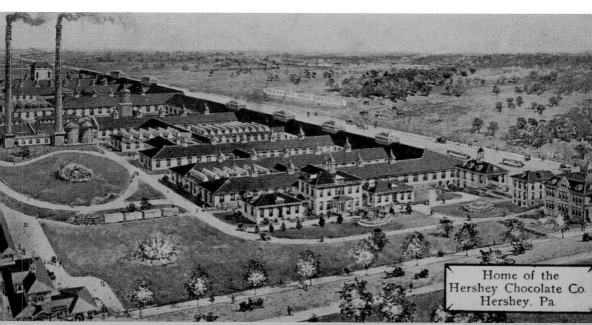

This postcard view of the Hershey chocolate factory along Chocolate Avenue indicates the sheer size of the facility around 1910. Known as a bar card, Hershey inserted these chocolate-bar sized postcards into milk chocolate bars as a way to promote his company, town, and school as well as the wholesome ingredients and modern technology used in the chocolate-making process.

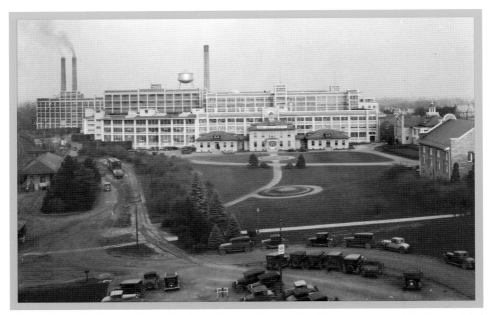

The rocky soil where Milton Hershey chose to build his factory yielded an abundance of limestone that the ever-resourceful entrepreneur reused in the construction of the factory and many town buildings. Completed in 1905, the two-story building in the center served as office space.

The two flanking structures originally provided separate locker rooms for men and women but were later converted to additional office space. The original one-story production buildings in the background quickly grew upwards to accommodate increased demand.

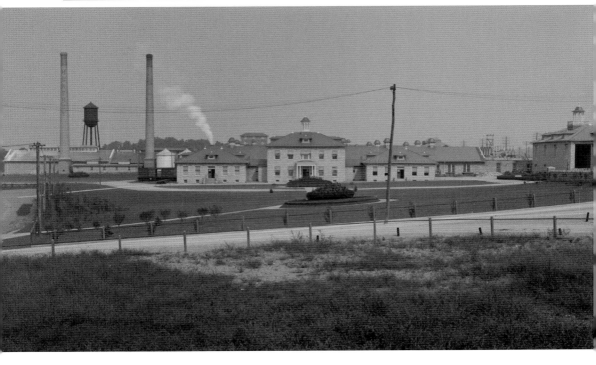

THE LARGEST CHOCOLATE FACTORY IN THE WORLD

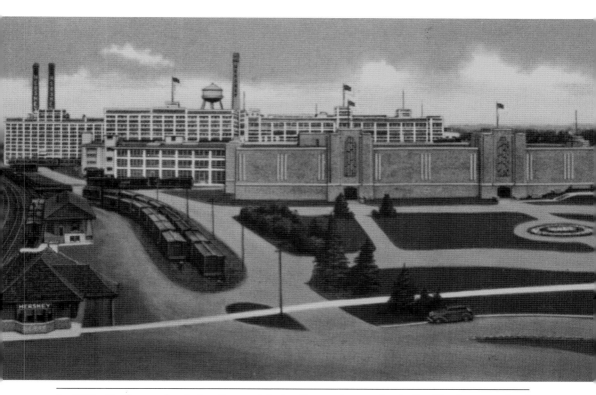

In 1935, Hershey replaced the three original administrative buildings with a larger facility known simply as the Windowless Office Building. Constructed in the Art Deco style popular at the time, the facility provided a tightly controlled, scientifically designed environment for employees. Ironically, Hershey retrofitted the building with sleek deco-inspired windows in 2014 to provide natural light and visual access of the outdoors to those inside. The Hersheypark monorail in the foreground opened in 1969.

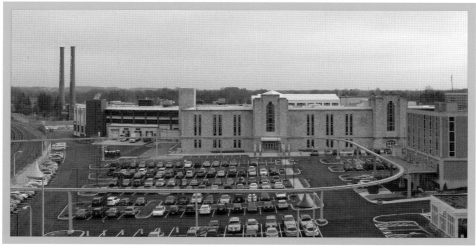

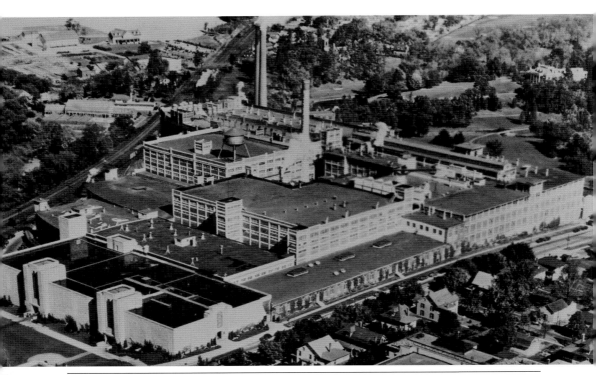

Milton Hershey envisioned his chocolate factory as an integral part of the downtown landscape; however, an aging infrastructure coupled with an increase in commercial, residential, and visitor traffic convinced The Hershey Company to open a second plant on the west side of town in February 1993. The downtown factory ceased production in April 2012, and demolition of what had become the world's largest chocolate factory at 2.5 million square feet began soon after. (Now image courtesy of Nathan Merkel.)

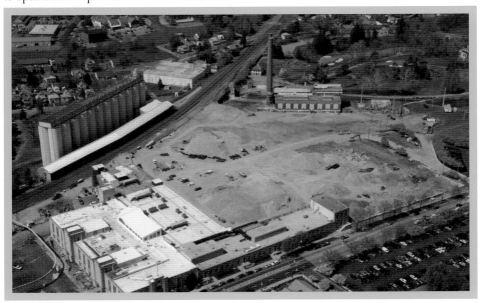

THE LARGEST CHOCOLATE FACTORY IN THE WORLD

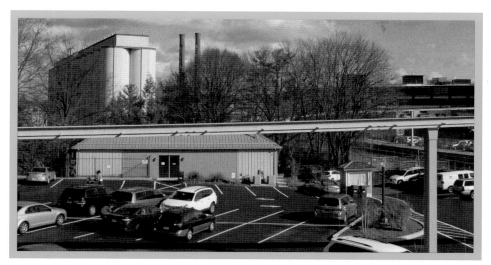

In August 1950, Hershey began around-the-clock-concrete pouring for 16 cocoa bean storage silos. The completed silos, towering 130 feet in height, held 60 million pounds of cocoa beans. In 1957, the company constructed an additional eight silos, increasing capacity to 90 million pounds of beans, enough to make 5.5 billion chocolate bars. In 2014, a private developer purchased the silos. Since 1978, facilities for ZooAmerica, North American Wildlife Park, have occupied much of the adjacent area.

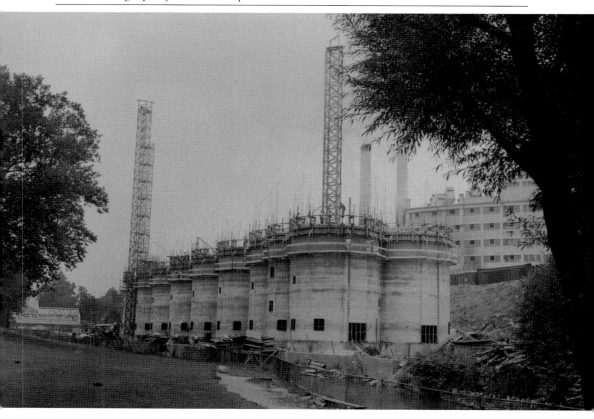

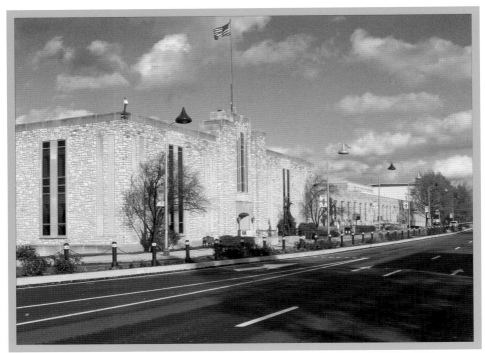

Despite razing a substantial portion of the downtown factory and relocating all manufacturing to the new West Hershey Plant, the chocolate company has committed to maintaining a presence in downtown Hershey. Both the Windowless Office Building as well as several adjacent structures will be retained as office space. The decorative lighted bollards in the center of Chocolate Avenue help manage both vehicular and pedestrian traffic and provide an aesthetic enhancement to the downtown area.

THE LARGEST CHOCOLATE FACTORY IN THE WORLD

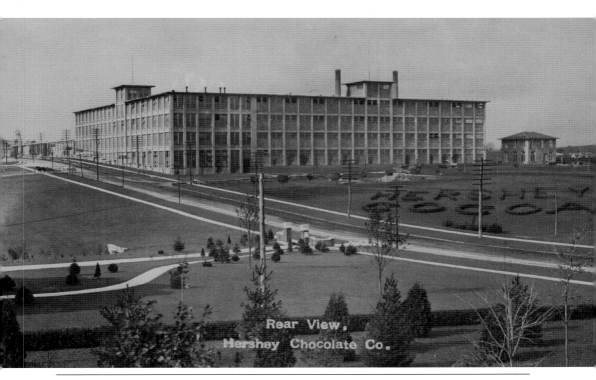

Rear View,
Hershey Chocolate Co.

Several iconic landmarks along the east end of the former downtown chocolate-making facility have also been preserved, including the red barberry bushes spelling HERSHEY COCOA as well as a nearby powerhouse and set of twin smokestacks marked HERSHEY. Streetlights in the shape of wrapped and unwrapped Hershey's Kisses chocolates were first installed along Chocolate Avenue in the fall of 1963. Over 100 of these fixtures can be found throughout the town.

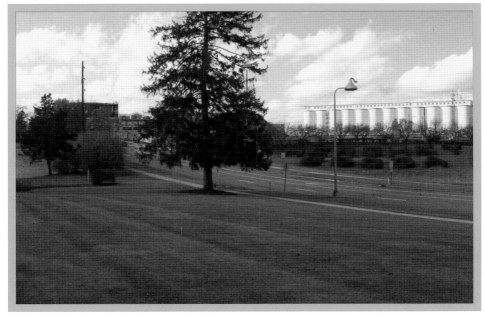

The three main ingredients in the manufacture of milk chocolate are cocoa, milk, and sugar. The pod of the cacao tree contains the beans from which cocoa is made. Cacao trees only thrive in countries lying between 20 degrees north and 20 degrees south of the Equator. The fruit of the cacao tree is the cocoa pod. Unlike most fruiting trees, pods grow directly from the trunk and large branches of a tree. (Now image courtesy of The Hershey Company.)

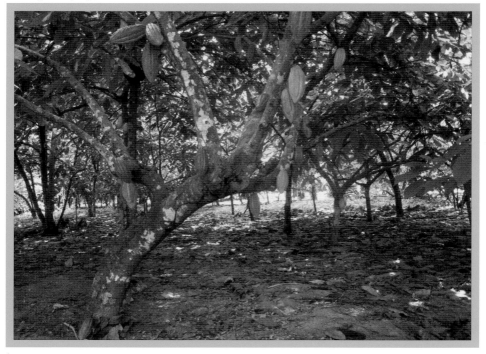

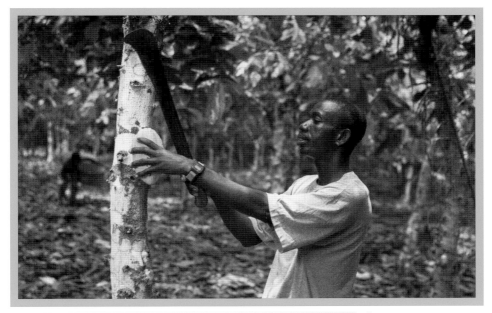

A mature cacao tree flowers continuously, with white and pink blossoms growing directly from the trunk. Over time, little has changed in the growing and harvesting of cocoa. At harvest time, pods are still cut from the trunk by hand using a machete-like tool called a *podadera* because the tree is too frail for climbing, and its roots are shallow. Only a small number of flowers will mature into pods. (Now image courtesy of The Hershey Company.)

THE LARGEST CHOCOLATE FACTORY IN THE WORLD

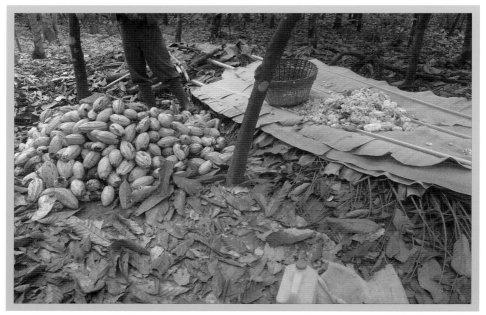

Once harvested from trees, pods are split open. Beans are then scooped from the pods and placed under leaves or in boxes and left to ferment several days until they become light brown in color. The pulp surrounding the beans liquefies as it ferments. Pods usually yield 40 to 60 beans each. It takes approximately 400 beans to make one pound of chocolate. (Now image courtesy of The Hershey Company.)

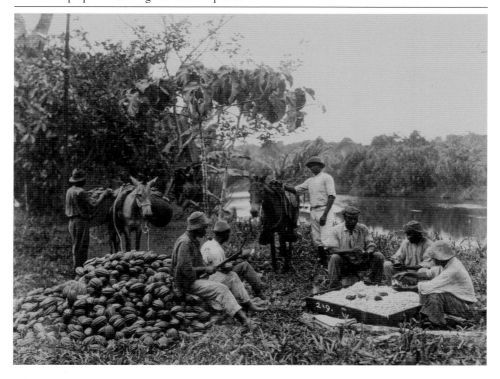

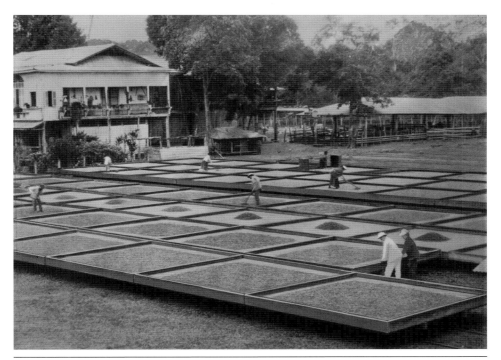

West Africa accounts for approximately 72 percent of the world's supply of cocoa beans. The Hershey Company has taken a leadership role in supporting programs to improve the lives of cocoa-farming families through a number of initiatives, including the Hershey Learn to Grow farmer and family development centers and CocoaLink, a first-of-its-kind approach that uses mobile technology to deliver practical information on agricultural and social programs to rural cocoa farmers. (Now image courtesy of The Hershey Company.)

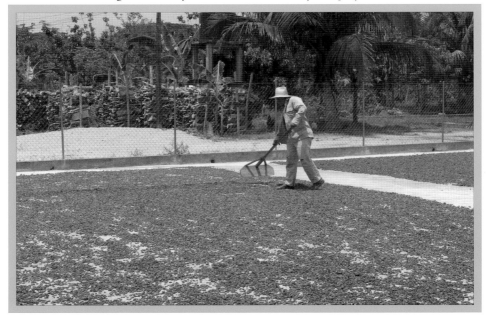

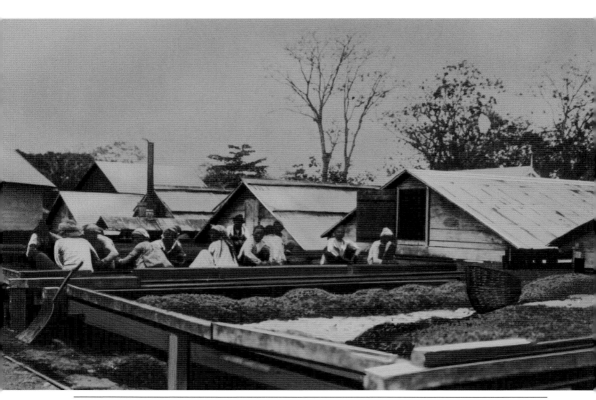

When fermentation is complete, beans still need to be spread out on the ground or on a table to be dried. Modern techniques include tables that can be slid under concrete platforms for protection, heated tables, electric dryers, or even covered drying rooms. Once the beans are dried, which usually takes one to two weeks, they are scooped into bags and shipped to various chocolate manufacturers. (Now image courtesy of The Hershey Company.)

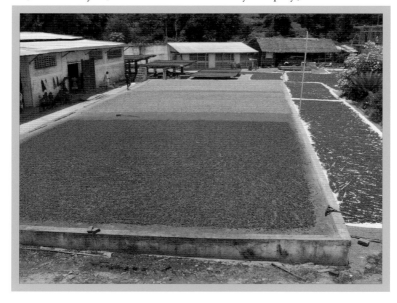

In 1894, Milton Hershey founded the Hershey Chocolate Company in the town of Lancaster, Pennsylvania, where he produced his first Hershey's milk chocolate bars in 1900. The factory in Hershey began producing chocolate in 1905, and the Hershey Chocolate Company became the Hershey Chocolate Corporation in October 1927. The company added nutrition information to its labels in 1973—a first in the confectionery industry—and universal product codes (UPC) in 1976. (Now image courtesy of The Hershey Company.)

Hershey introduced Hershey's Kisses chocolates in 1907. The first Hershey's Kisses chocolates were individually hand-wrapped in plain squares of foil. With the advent of mechanical wrapping machines in 1921, Hershey added the now-familiar flag or plume to immediately identify individual pieces as genuine. Though Kisses chocolates come in a variety of flavors, the plume remains a central component of product identification and advertising. Today's machines can wrap up to 1,300 Kisses chocolates per minute or 70 million each day. (Now image courtesy of The Hershey Company.)

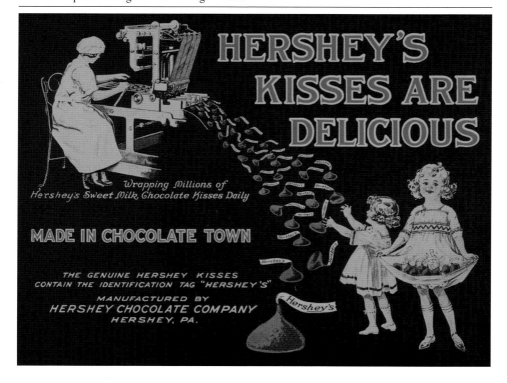

THE LARGEST CHOCOLATE FACTORY IN THE WORLD

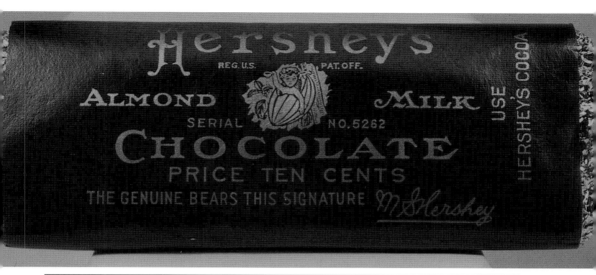

In 1908, Hershey began to manufacture Hershey's milk chocolate bars with almonds. Hershey's demand for almonds grew so great that the company began buying land to develop almond groves in California in 1965. Before selling the land in 1977, Hershey owned over 5,000 acres of almond orchards. In April 2003, Hershey discontinued use of the traditional foil-and-paper wrapper in favor of a single fin-seal encapsulating wrapper that is still used today. (Now image courtesy of The Hershey Company.)

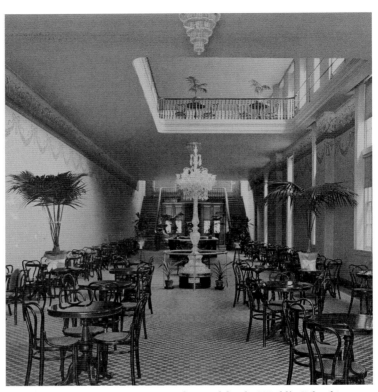

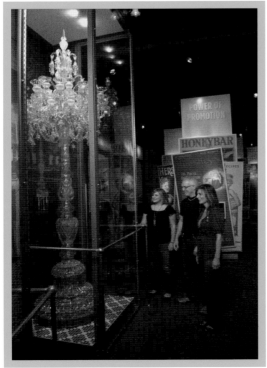

Fabricated for the World's Columbian Exposition in 1893 by the L. Straus Company of New York City, Milton Hershey purchased this crystal torchère in 1901 to help attract customers to his soda fountain and candy store located at 1020 Chestnut Street in Philadelphia. The largest composite cut-glass article produced to that time, the torchère is currently on exhibit at The Hershey Story, The Museum on Chocolate Avenue. (Now image courtesy of The Hershey Story.)

THE LARGEST CHOCOLATE FACTORY IN THE WORLD

CHAPTER

MILTON S. HERSHEY

THE MAN BEHIND THE CHOCOLATE BAR

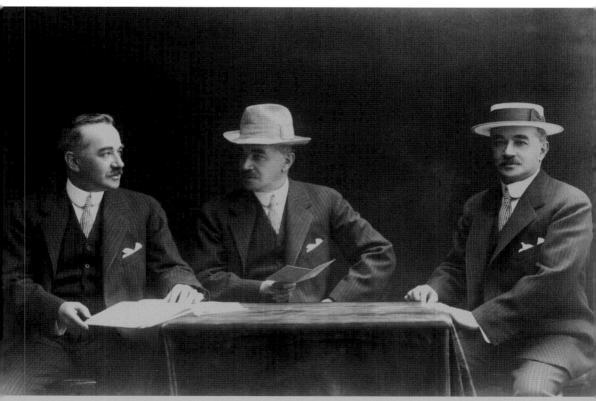

Milton Hershey founded the Hershey Chocolate Company in 1894, the town of Hershey in 1903, and the Hershey Industrial School in 1909. He and his wife, Catherine, enjoyed traveling, especially to Nice on the French Riviera, where this whimsical photograph was taken in 1910. Following Catherine's death in 1915, Milton devoted his energies to nurturing the school they created together.

Milton Hershey's first business success was not in chocolate but in caramels. In 1886, he founded the Lancaster Caramel Company in the town of Lancaster (about 30 miles east of the town of Hershey) after experiencing several business failures. The chocolate company began operating in this facility as a subsidiary of the caramel company in 1894. Today, the site is occupied by Church Street Towers, a public housing facility operated by the Lancaster City Housing Authority since 1968.

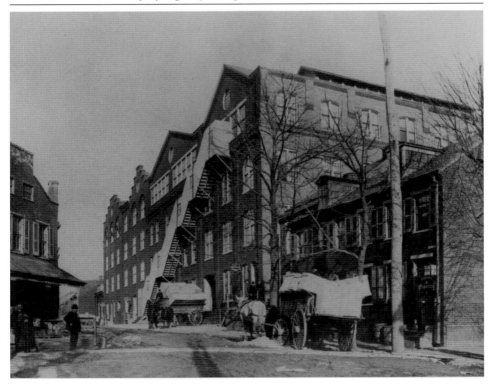

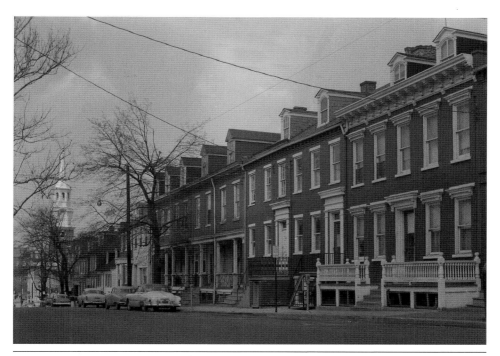

Between 1888 and 1891, Milton Hershey lived in the 100 block of South Duke Street with his mother, just one block from the caramel company building on Church Street. The revitalization and widening of Church Street in the 1960s resulted in the loss of the caramel company building as well as the home of Milton Hershey. Today, the row of homes ends just before Milton Hershey's former home.

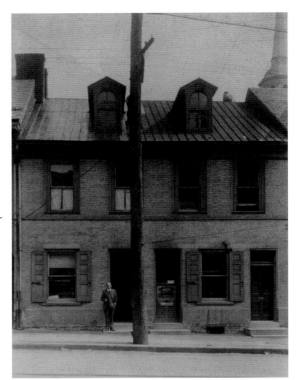

John E. Snyder served as Milton Hershey's personal and corporate lawyer in Lancaster as well as in Hershey. His law office on the second block of East King Street in Lancaster was on the first floor of a building that also served as the residence of noted Lancaster artist Charles Demuth. The building is now home to the Demuth Museum. The steeple of Holy Trinity Lutheran Church is in the background.

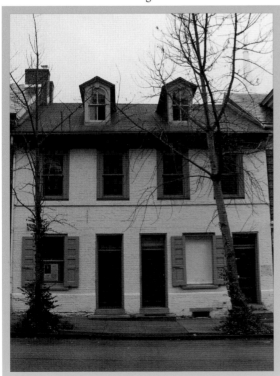

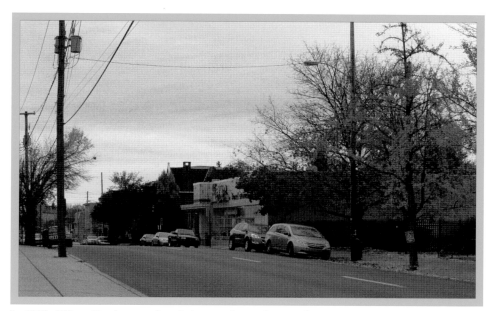

In 1892, Milton Hershey purchased this stately home on the 200 block of South Queen Street in Lancaster. He lived here with his mother from 1892 until his marriage to Catherine in 1898. After purchasing another home for his mother, Hershey and his wife lived here until they relocated to Hershey in 1905. The mansion was razed in 1951 to make way for a supermarket.

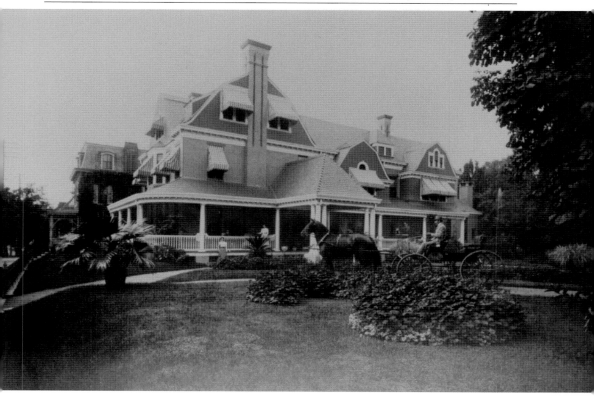

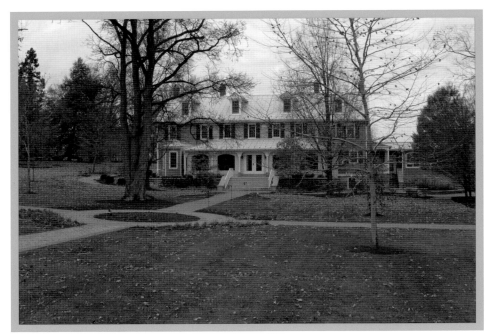

Isaac and Anna Hershey, great-grandparents of Milton Hershey, constructed the original stone portion of The Homestead in 1826 for their son Jacob. Both Milton and his father, Henry Hershey (1829–1904), were born here. Milton Hershey used the barns and outbuildings around The Homestead to perfect his milk chocolate formula. The Homestead served as the residence of Milton and Catherine Hershey between 1905 and 1908, while their new home, High Point, was under construction.

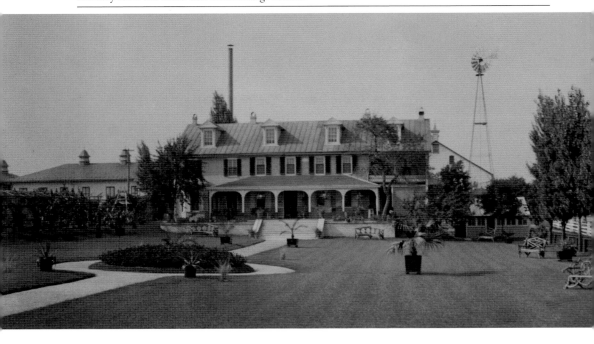

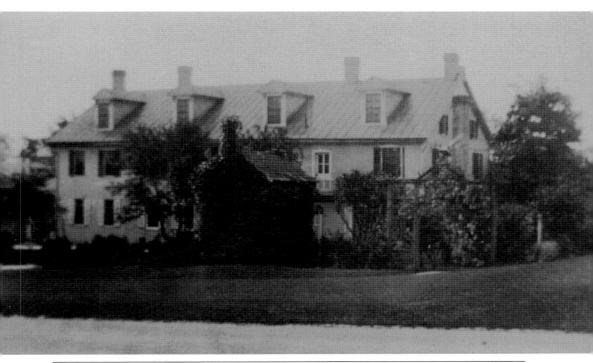

Located on the campus of Milton Hershey School, The Homestead served as the first home and school for the boys of the Hershey Industrial School. After 1917, students no longer lived at The Homestead, though it continued to be used as a home for staff, including several school presidents. Recent improvements to The Homestead include the construction of a garage addition in 2010 and the cleaning and repointing of the original stone in 2013.

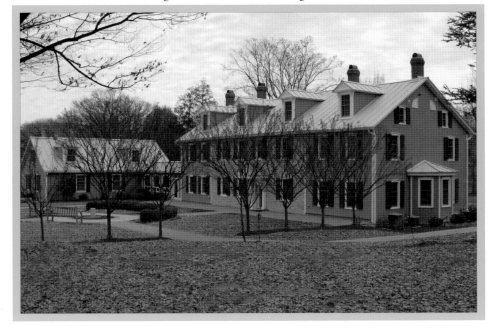

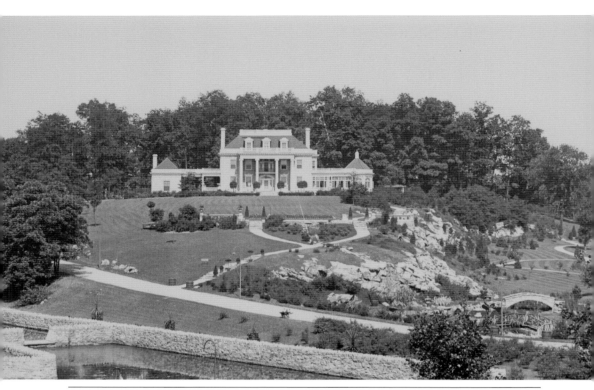

While gracious and comfortable, High Point was relatively modest when compared to homes of Hershey's peers. Hershey spent approximately $100,000 on the construction, furnishings, and landscaping of what became known simply as the Mansion. Designed by noted local Lancaster architect C. Emlen Urban, the house itself cost $53,433. The staff at High Point consisted only of a housekeeper, houseman, and housemaid. Though no longer a home, the exposed rock and decorative concrete and stone landscape features remain.

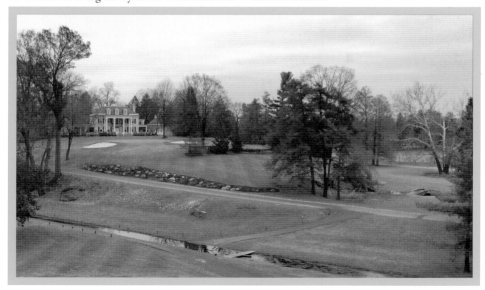

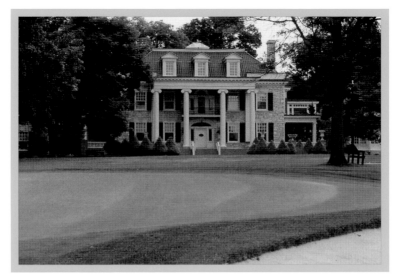

In this photograph taken in 1912, Milton and Catherine Hershey can be seen entertaining guests on their front porch. Following Catherine's death in 1915, Milton Hershey continued to make High Point his home. In 1930, Hershey constructed a complete 18-hole golf course on the grounds surrounding High Point and donated use of his home to the Hershey Country Club, keeping only a small apartment on the second floor as his personal residence.

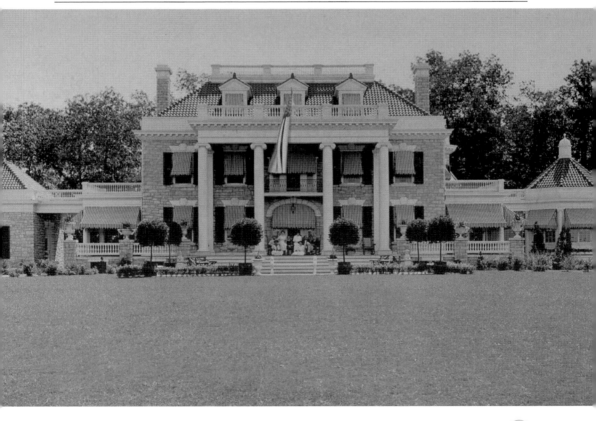

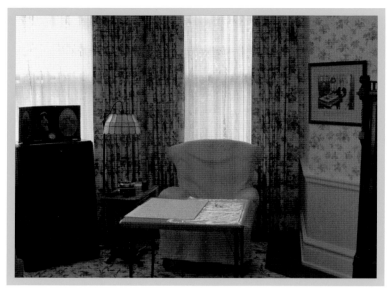

The small two-room apartment kept by Milton Hershey in High Point included a bedroom and separate sitting room. Taken in 1937, this is the only known photograph of the apartment interior. Now home to the Hershey Trust Company, trustee for the Milton Hershey School Trust, High Point is not open to the public; however, re-created room vignettes throughout the house provide opportunities for students and staff of Milton Hershey School to learn about the lives and values of the Hersheys.

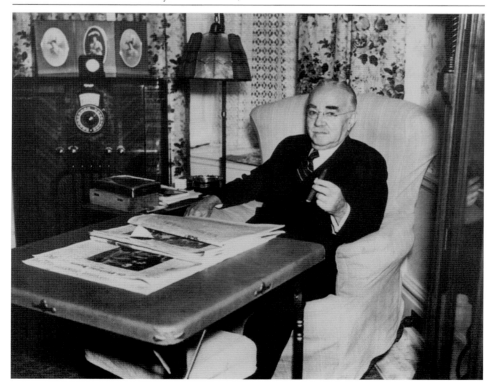

MILTON S. HERSHEY

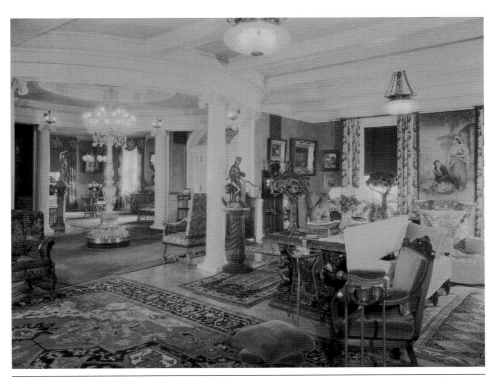

While Milton Hershey had the entrance foyer of High Point designed to feature the crystal torchère from his Philadelphia store, the rest of High Point was decorated quite modestly, with manufactured furniture of good quality and souvenirs of their travels. Though they could have afforded the best furnishings, the Hersheys chose to instead use their money to enrich the community and school they founded. Today, the living room has been enclosed by glass and serves as a board and meeting room.

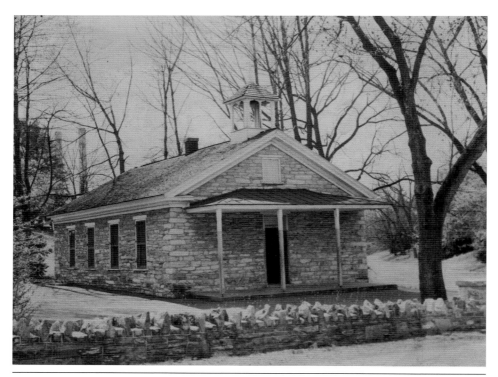

Located on the grounds of High Point, the Derry Church School was a one-room schoolhouse attended by Milton Hershey for one year (1863–1864). At one time, the building was used as a caddyhouse for the Hershey Country Club. Restored in the 1950s by carpentry students from Milton Hershey School, the structure is furnished to show what a one-room schoolhouse might have looked like in the 19th century.

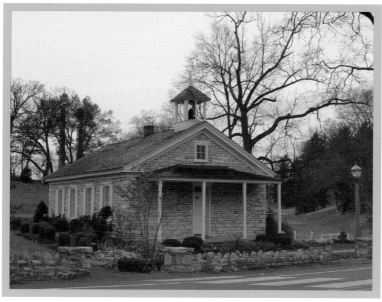

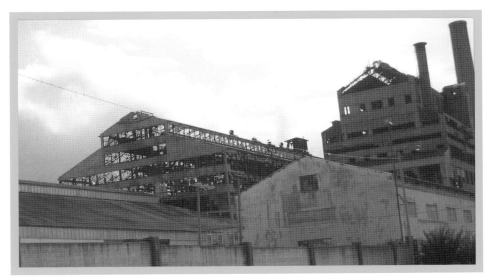

To help ensure a steady supply of sugar for his chocolate, Milton Hershey began to acquire land in Cuba in 1916, shortly after the death of his wife. More than an investment, Cuba became a place of refuge for Hershey. He eventually acquired several mills and built a new mill and town known as Central Hershey. Both the mill and the town around it have deteriorated as the Cuban economy continues to struggle. (Now image courtesy of the Frech Family Collection, Hershey Community Archives.)

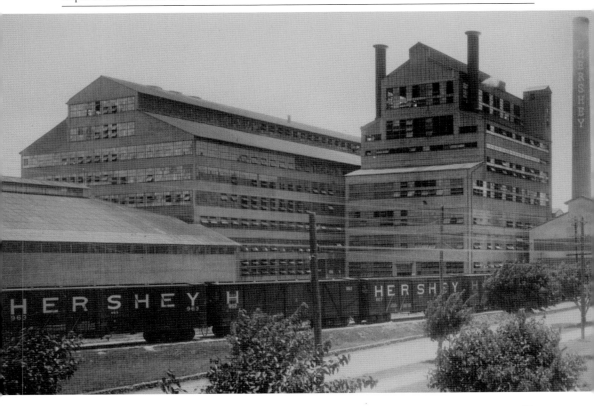

Central Hershey was the flagship of Hershey's Cuban holdings. In 1922, Hershey constructed an electric railroad between the major ports of Havana and Matanzas to transport his sugar, portions of which continue to operate today. Central Hershey was renamed Central Camilo Cienfuegos in 1959, in honor of the Cuban revolutionary who fought with Fidel Castro. (Then image courtesy of Hershey Community Archives; now image courtesy of the Frech Family Collection, Hershey Community Archives.)

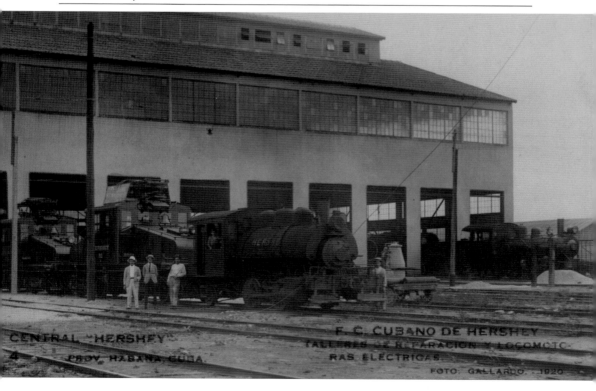

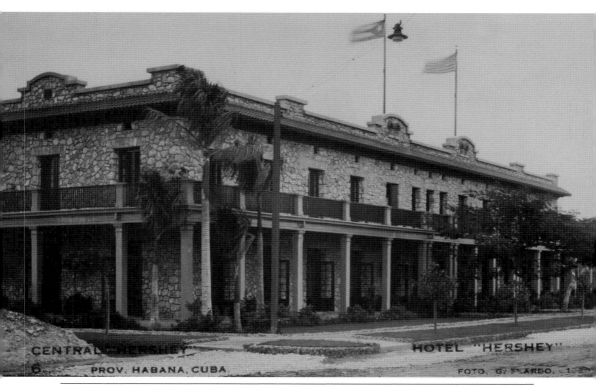

Located about 35 miles east of Havana, Central Hershey included many of the same amenities found in its Pennsylvania counterpart. Cuba's Hotel Hershey, though not as large or ornate as its Pennsylvania namesake, was once a beautiful building that became an apartment building after the Cuban Revolution. The structure was already in need of rehabilitation when Hurricane Ike tore the roof off the building in 2008. (Then image courtesy of Hershey Community Archives; now image courtesy of the Frech Family Collection, Hershey Community Archives.)

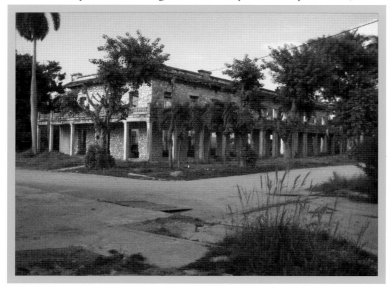

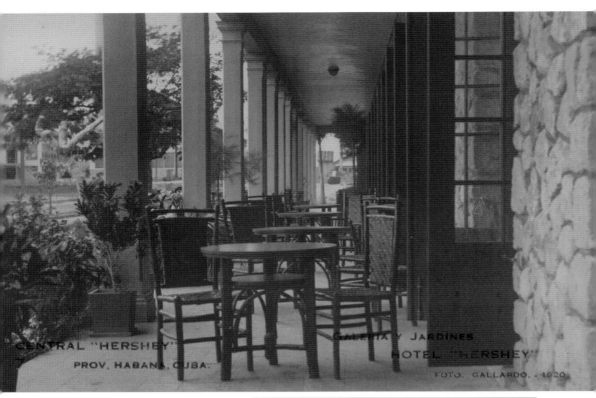

CENTRAL "HERSHEY" PROV, HABANA, CUBA.

GALERIA Y JARDINES HOTEL "HERSHEY"

FOTO. GALLARDO. - 1920

The verandas of Cuba's Hotel Hershey were once gracious and welcoming. Milton Hershey was greatly admired in Cuba for his way of doing business and for his philanthropy. In 1933, he received the Grand Cross of the National Order of Carlos Manuel de Cespedes, the highest honor Cuba could bestow on a foreigner. In 1946, the company sold all its Cuban interests to the Cuban Atlantic Sugar Company. (Then image courtesy of Hershey Community Archives; now image courtesy of the Frech Family Collection, Hershey Community Archives.)

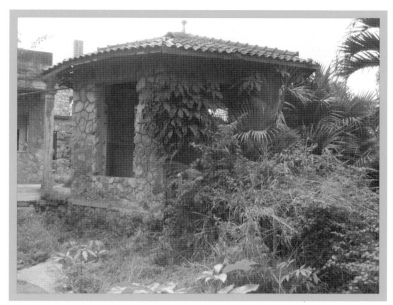

Milton Hershey spent a great deal of time in Cuba, especially enjoying the private dining room at The Hotel Hershey. At the neighboring town of Rosario, Hershey also founded an orphan school, the Hershey Agricultural School. Like the Hershey Industrial School in Pennsylvania, the Cuban school prepared young boys for careers in agriculture or industry. (Then image courtesy of Hershey Community Archives; now image courtesy of the Frech Family Collection, Hershey Community Archives.)

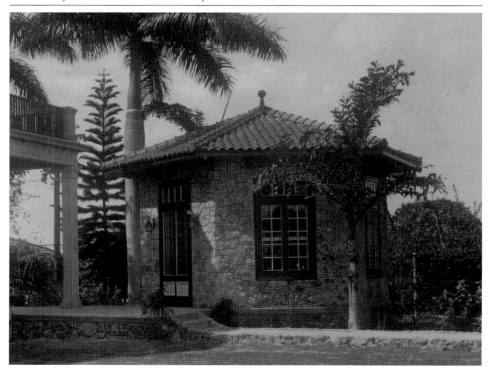

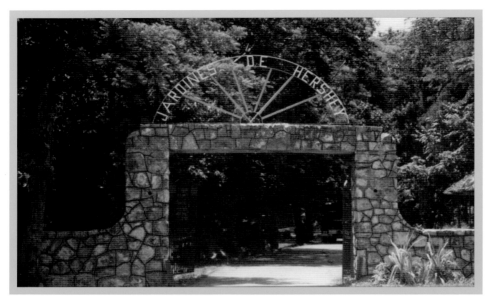

Despite the changes that have occurred in Cuba since the 1959 revolution, the town of Central Camilo Cienfuegos is still referred to as Hershey by many older residents who take pride in the amenities and advantages the town once offered. Signs with the name of Hershey can still be seen in various places around the town, including the formal entranceway to the Jardines de Hershey (Hershey Gardens). (Then and now images courtesy of Hershey Community Archives.)

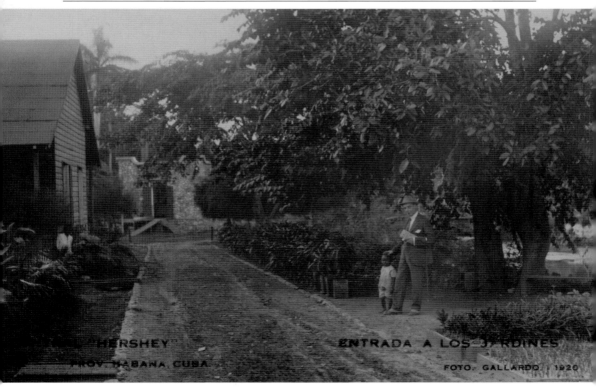

CHAPTER 3

HERSHEY, PENNSYLVANIA

A MODEL COMMUNITY
TAKES SHAPE

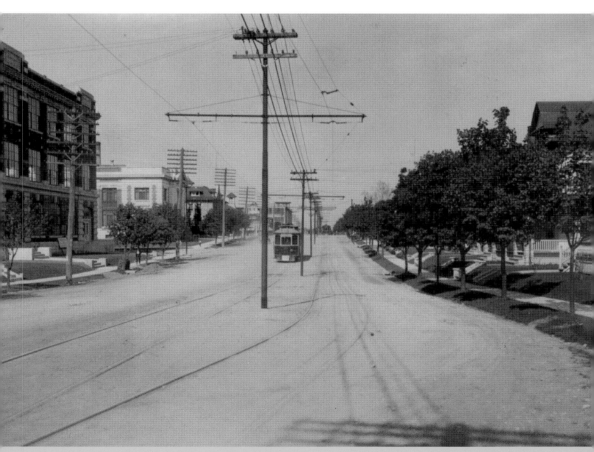

Despite dramatic changes to the streetscape since 1903, Chocolate Avenue continues to serve as the main thoroughfare for the town. As the town continues to grow and evolve, new construction and the adaptive reuse of existing historical structures have helped the town remain a popular destination for visitors and a desirable place to live and work.

HERSHEY, PENNSYLVANIA

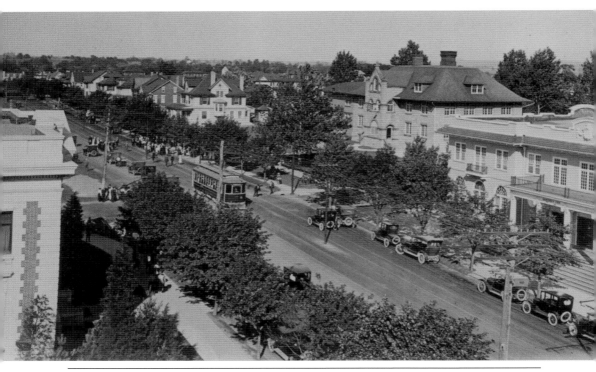

By 1920, Chocolate Avenue boasted a number of homes as well as buildings essential to the operation of the town. These included the Hershey Trust Company building (far left), Hershey Inn (far right), and McKinley School (right center). The Hershey Community Building (below) now occupies the site of the McKinley School. Kiss-shaped streetlights along Chocolate Avenue were first installed in 1963. Affectionately referred to as Hinkle's Twinkles by locals in honor of then chocolate company president Sam Hinkle, each fixture was fitted with high pressure sodium lights in March 1991.

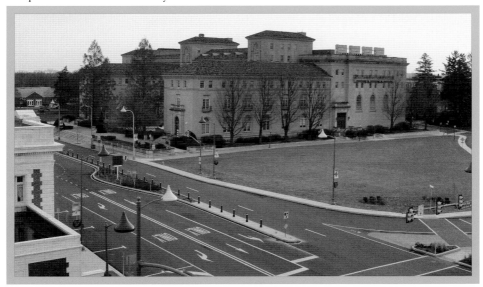

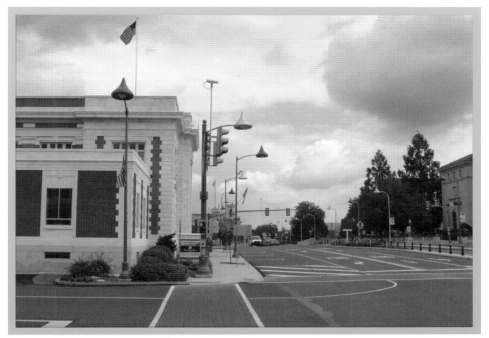

Completed in 1932, the massive community building (right rear) replaced the McKinley School at the intersection of Cocoa and Chocolate Avenues. In 1936, the Hershey Inn (right foreground) was remodeled with two additional floors and renamed the Community Inn. Renamed the Cocoa Inn in 1958, the building was demolished in 1970 by explosives and replaced by a single-story, red-brick structure. In 2013, that building was also demolished, paving the way for realignment of the busy intersection, completed in 2014.

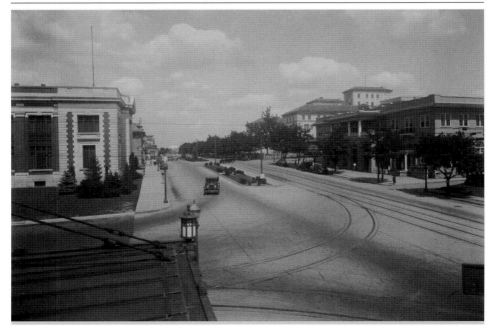

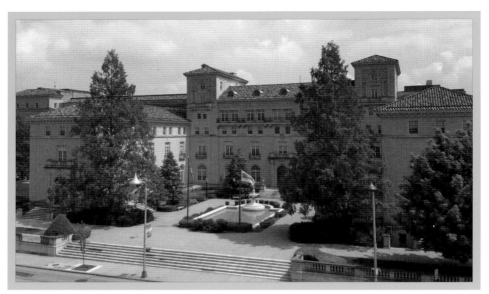

Located at the southeast corner of Chocolate and Cocoa Avenues, the six-story Hershey Community Building covers nearly six acres of floor space. Executed in the Italian Renaissance style, the building originally housed a number of recreational facilities, including a gymnasium, indoor swimming pool, and bowling alley, as well as a public library, junior college, and community hospital. The structure is still home to the Hershey Theatre and since 1982 also serves as the Corporate Administrative Center for The Hershey Company.

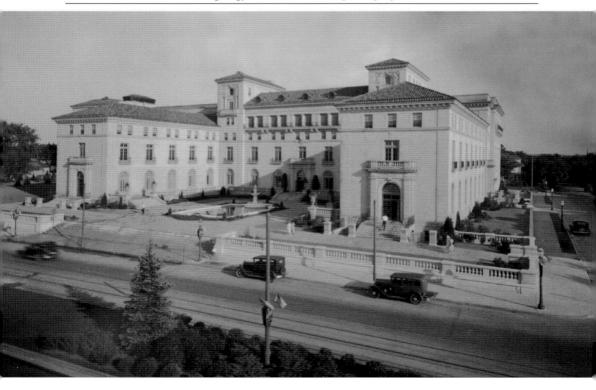

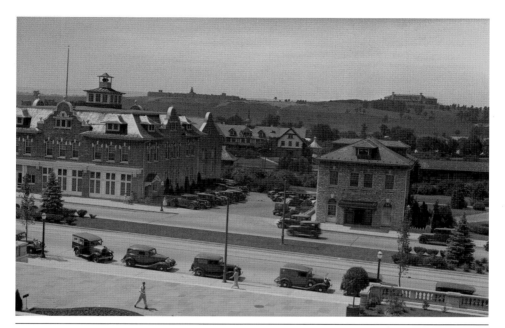

Though all of the buildings pictured here along the north side of Chocolate Avenue have been demolished, two iconic buildings on the crest of a hill overlooking the town remain. The Hotel Hershey (right) opened in 1933. The Junior-Senior High School (now Catherine Hall) of Milton Hershey School (left) opened in 1934. Much of the land between Chocolate Avenue and the base of the hill is dominated by Hersheypark, including the 250-feet-high rotating Kissing Tower (far left).

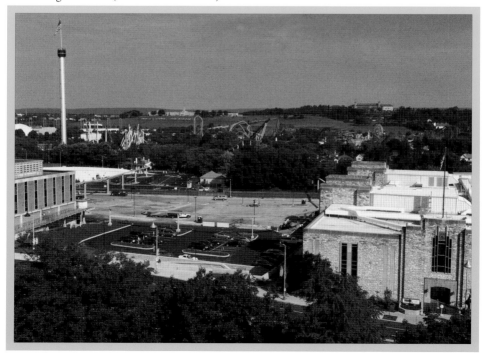

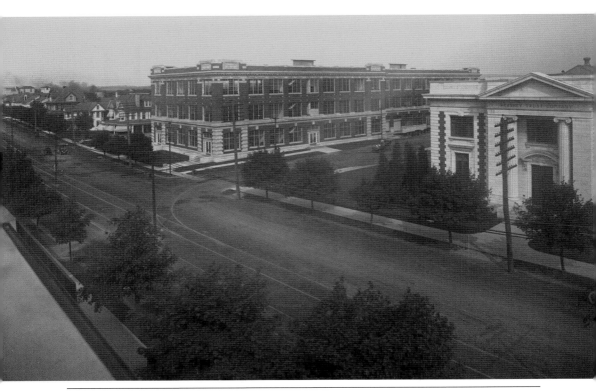

Iconic buildings along the north side of Chocolate Avenue include the Hershey Trust Company building (right), completed in 1914, and the Hershey Press building (center), completed in 1916. Opened in January 2009, The Hershey Story, The Museum on Chocolate Avenue (left) is the first landmark building to be constructed on Chocolate Avenue since the 1930s. Located across from The Hershey Story, ChocolateTown Square park offers a relaxing downtown green space and a venue for summertime concerts.

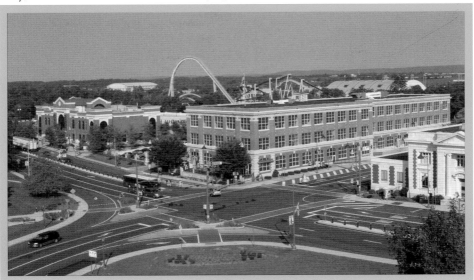

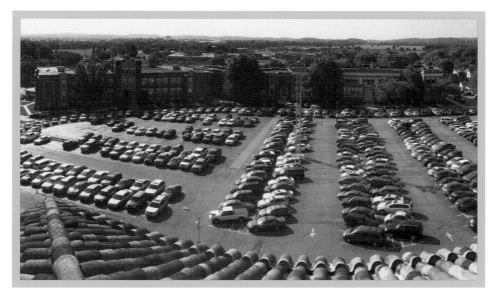

Milton Hershey built and donated the M.S. Hershey Consolidated School (far right) in 1914 to replace the McKinley School. As the student population of the public school system continued to grow, Milton Hershey added the Hershey Junior-Senior High School (far left) in 1925. Milton Hershey strongly believed in the value of vocational education and constructed the Hershey Vocational School (center) in 1929 to complete the public school's shared campus, now home to school district offices as well as various local businesses.

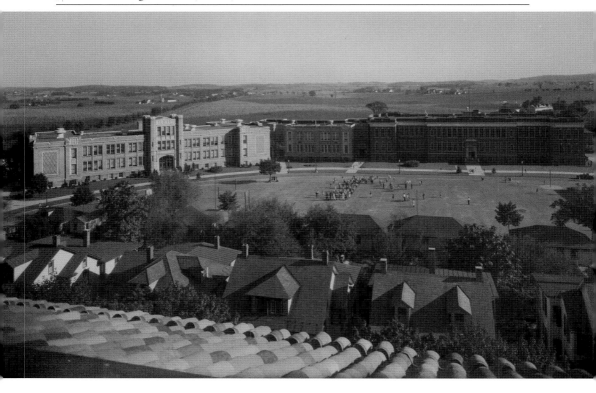

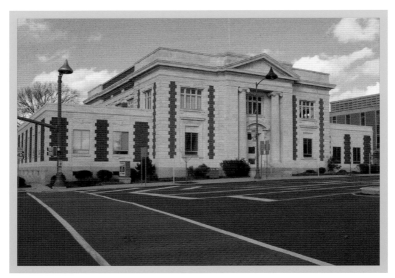

Completed in 1914, the marble-and-brick Hershey Trust Company building was designed to impress the public as well as to inspire confidence. In 1925, the structure became the banking as well as financial center for the town, with the addition of a separate operating entity known as the Hershey National Bank. The two wings were added to the building in 1967. The structure is currently home to Northwest Savings Bank and Bryn Mawr Trust Wealth Management.

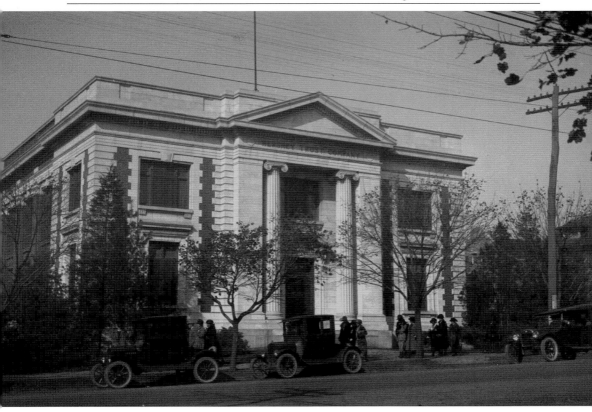

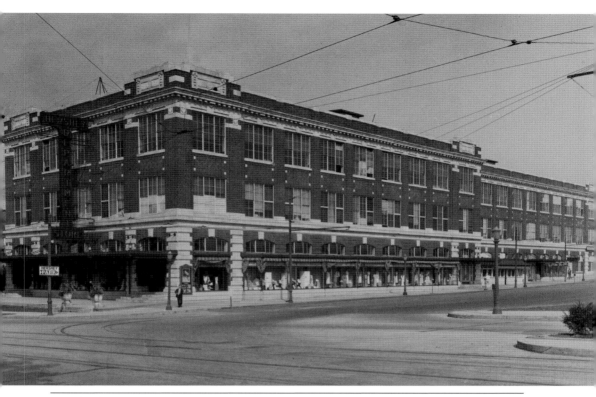

Completed in 1916 as the Hershey Press Building, this structure served as home to the Hershey Department Store from 1920 until 1971. Following substantial alterations by a succession of tenants (including the addition of bright gold aluminum siding over many of the windows in the 1970s), the building has been restored to its original luster and name by Hershey Entertainment & Resorts Company, a Hershey corporate entity, to house its corporate offices and a mix of business and dining establishments.

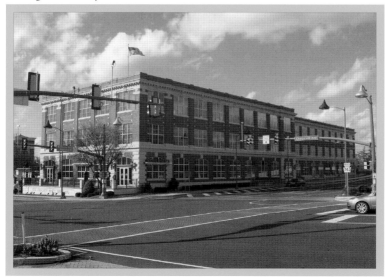

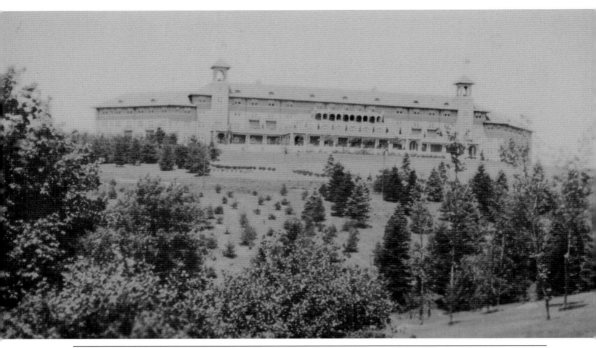

Building a grand hotel on top of Hershey's highest point was part of Milton Hershey's earliest plans for his model community. Opened in 1933, The Hotel Hershey incorporates design elements inspired by Mediterranean trips taken by Hershey with his wife, Catherine. Originally consisting of 170 rooms, The Hotel Hershey now includes 276 rooms and has been designated a Historic Hotel of America by the National Trust for Historic Preservation and has earned a AAA Four Diamond rating.

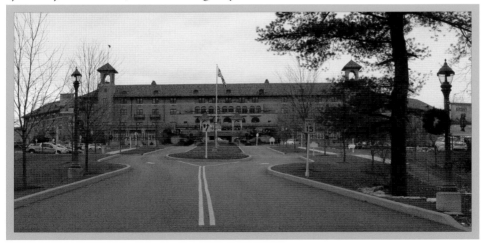

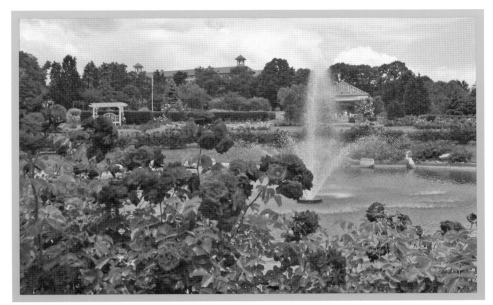

Hershey Gardens opened in 1937 as the Hershey Rose Garden. Located on 3.5 acres adjacent to The Hotel Hershey, the gardens have grown to include 23 acres of botanical beauty. Exhibits include 11 themed gardens, a butterfly house, and a children's garden. Swan Lake provides irrigation and is home to a reproduction of the *Boy with the Leaking Boot* statue that once graced the private gardens at High Point. (Now image courtesy of Hershey Gardens.)

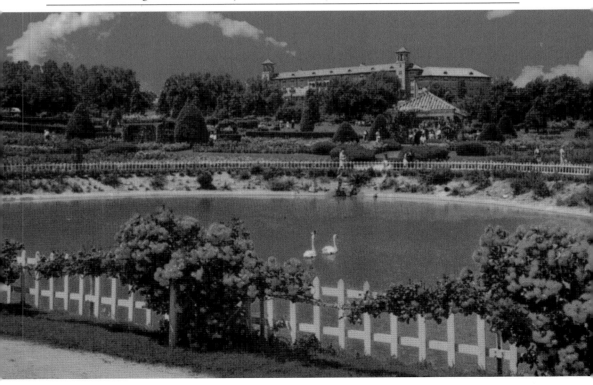

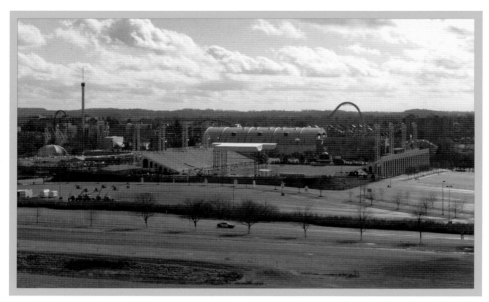

Completed in 1939, the multi-purpose Hershey Stadium (foreground) holds 16,000 fans for sporting events and 30,000 fans for concerts. The Hershey Sports Arena (left) was the largest single-span concrete structure in the world at the time of its completion in 1936. The arena was the site of Wilt Chamberlain's 100-point game between the Philadelphia Warriors and New York Knicks on March 2, 1962. The adjacent Hershey Convention Hall and Ice Palace (right) was completed in 1915.

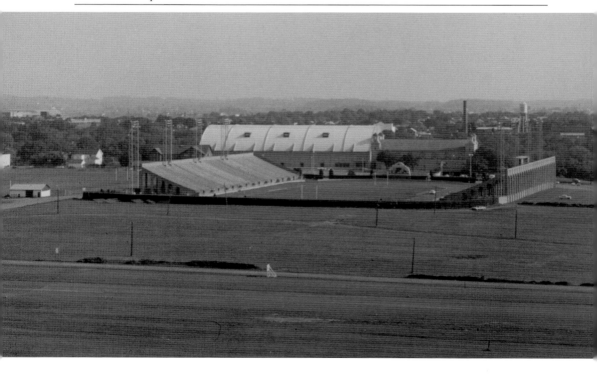

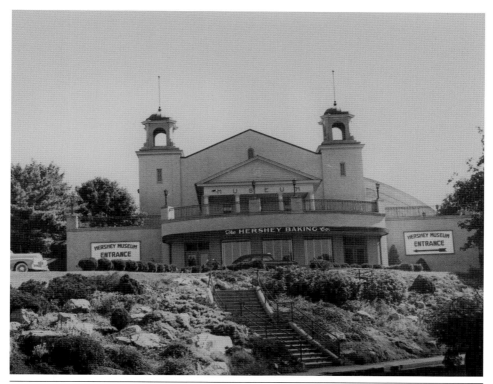

In 1938, Milton Hershey opened the Hershey Museum in the former Hershey Convention Hall and Ice Palace. In 2009, the museum relocated to a new facility with a new name. The Hershey Story, The Museum on Chocolate Avenue provides visitors with an opportunity to learn about everything Hershey and to explore the unique qualities of chocolate in a hands-on Chocolate Lab. Along with the stadium and arena, the former museum building is now part of the Hersheypark entertainment complex. (Now image courtesy of The Hershey Story.)

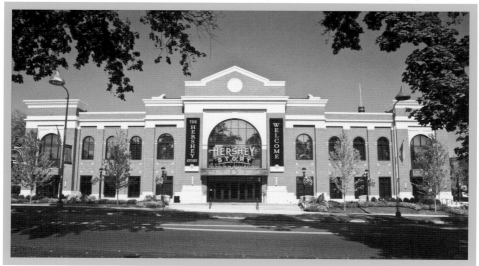

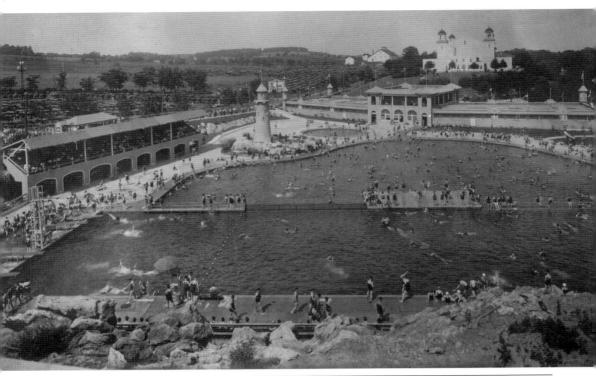

The lighthouse is the only remaining part of the Hershey Park swimming pool complex, open from 1929 through 1967. Following damage from Tropical Storm Agnes in 1972, Hershey razed the bathhouses, filled in the swimming pool, and has since expanded the theme park.

The lighthouse was reconditioned and landscaped in 2005. The arched form of the Hershey Sports Arena (now Hersheypark Arena), smokestacks of the factory, and cocoa bean storage silos can be seen in the background.

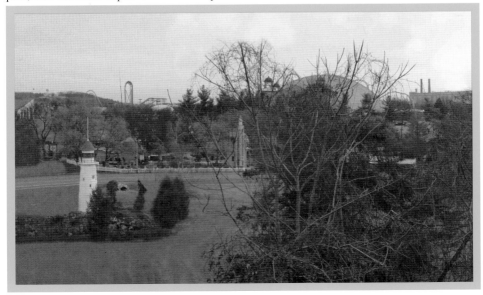

Milton Hershey's vision of a model community included opportunities for relaxation and recreation in Hershey Park. Once a simple picnic and playground for employees and visitors, Hersheypark has been a themed amusement park since 1971. Hersheypark now offers a variety of shows, games, and over 65 rides and attractions, including 20 kiddie rides, 14 water attractions, and 12 roller coasters.

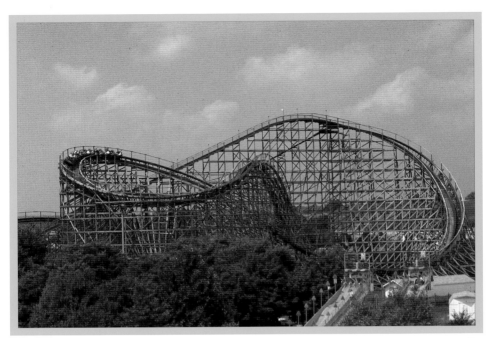

The Wild Cat, the first roller coaster in Hershey Park, opened in 1923 as a gift from Milton Hershey to celebrate the 20th anniversary of the founding of the town. The wooden roller coaster operated through the 1945 season when it was replaced by the Comet, a new coaster still in operation. Today, Hersheypark includes 12 roller coasters, including the Wildcat, a wooden roller coaster opened in 1996, named after the original Wild Cat. (Now image courtesy of Hershey Entertainment & Resorts Company.)

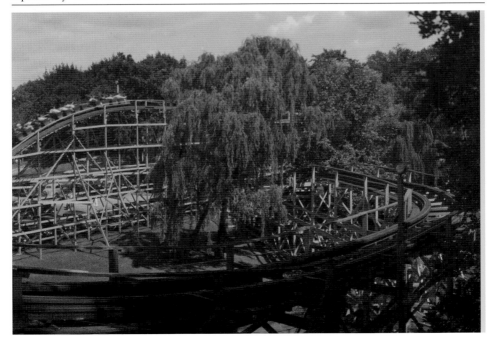

4

HERSHEY'S CHOCOLATE TOWN

A TOWN TO MEET EVERY NEED

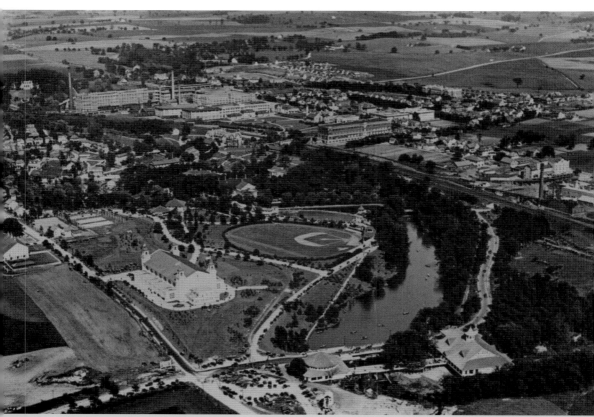

From its founding in 1903, Milton Hershey intended to build much more than a company town. With the chocolate factory as its centerpiece, his model community included well-designed homes, parks, and schools. The rural nature of the area also insured Hershey with a ready supply of fresh milk for his milk chocolate product.

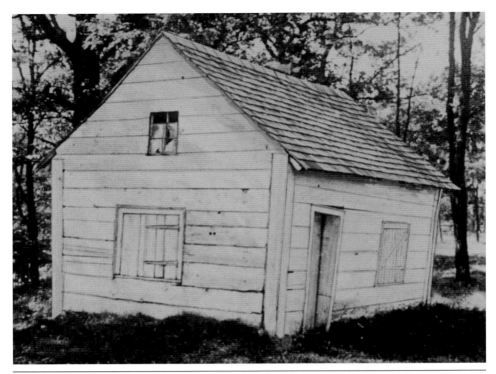

The earliest settlers to the Hershey area were Scots-Irish Presbyterians who founded the community of Derry Church in 1729. The Derry Session House, located on the grounds of Derry Presbyterian Church along East Derry Road, was constructed in 1732. The logs were covered by thick weatherboarding in 1810 and the building enclosed in glass for preservation in 1929 by Milton Hershey. The session house and enclosure were added to the National Register of Historic Places in 2006.

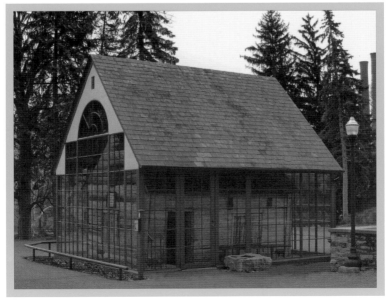

HERSHEY'S CHOCOLATE TOWN

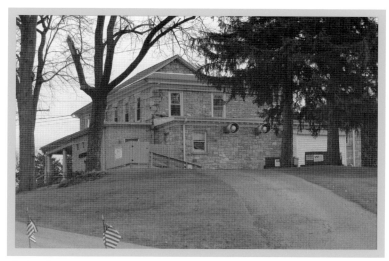

Dr. Martin L. Hershey (1857–1922), a prominent local physician and distant relative to Milton Hershey, lived in this home along East Derry Road where he also practiced medicine. Dr. Hershey served as Milton Hershey's personal physician for many years, and his daughter Ruth became a friend and travelling companion of Catherine Hershey. In 1933, the building became home to the Hershey American Indian Museum and in 1938 to American Legion Post No. 386, which continues to use the building.

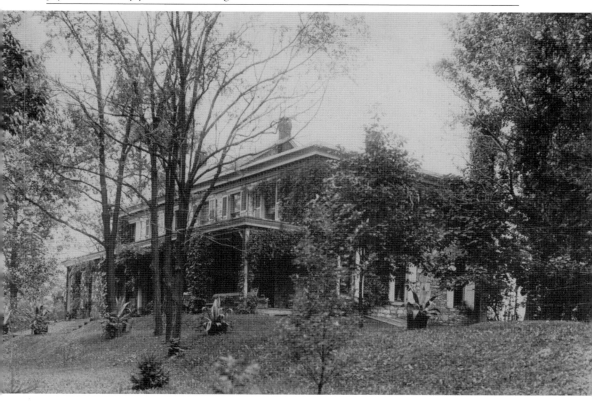

After World War II, the town of Hershey continued to expand into the established neighborhoods of Derry Church. This view of new homes under construction along East Derry Road includes two examples built by students of Milton Hershey School as part of the vocational education program. These include No. 459, completed in 1948 (far left), and No. 479, completed in 1949 (with ladder at roof). The brick building in the background is former Milton Hershey School student farmhome Oakleigh.

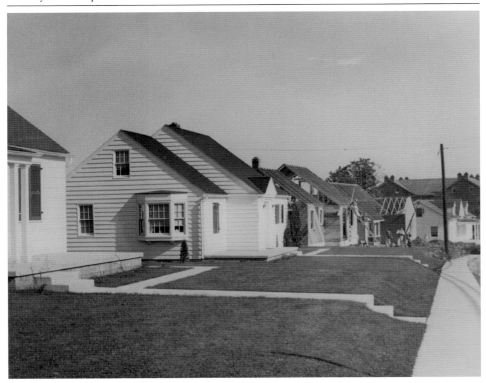

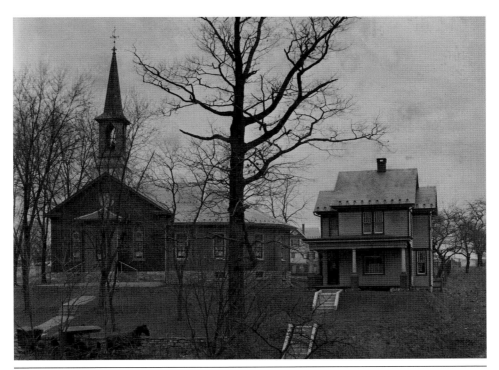

Salem United Brethren Church of Hershey (now the First United Methodist Church of Hershey) worshiped in this building on Park Avenue near its intersection with East Derry Road until construction of a new church at the intersection of Chocolate Avenue and Linden Road in 1928. Before moving, the church expanded several times, adding a parsonage (right) in 1903 and an addition to the main church (center) in 1912. Both buildings are now private residences.

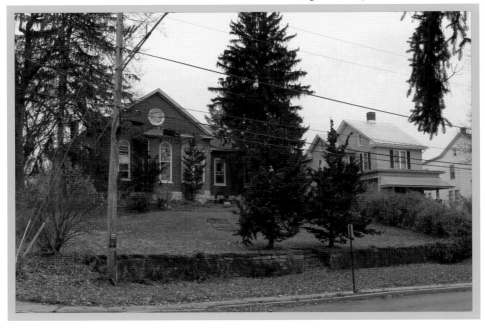

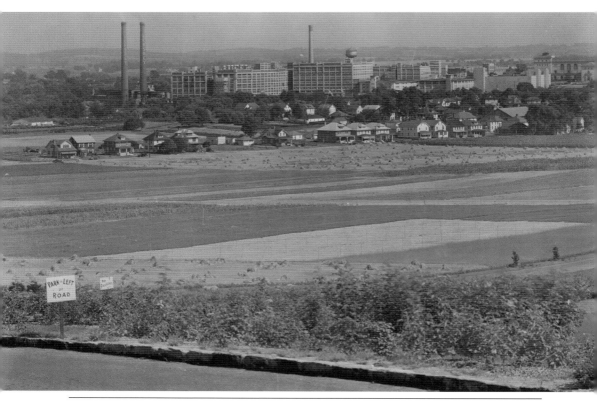

Though many of the homes remain, the area around Park Avenue has changed considerably as Hersheypark has grown from a simple picnic park to a world-class themed amusement park. Today, Hersheypark includes 12 thrilling roller coasters, including Wildcat (center), which opened in 1996, and Lightning Racer (far left), which opened in 2000 as the first wooden racing/dueling coaster in the United States. Both coasters are located in the Midway America section of Hersheypark.

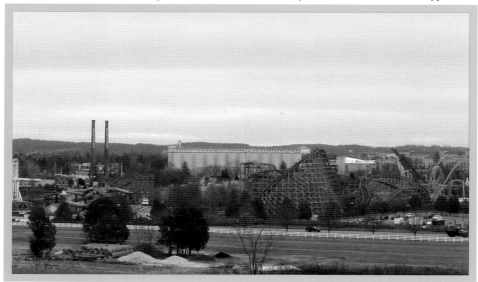

HERSHEY'S CHOCOLATE TOWN

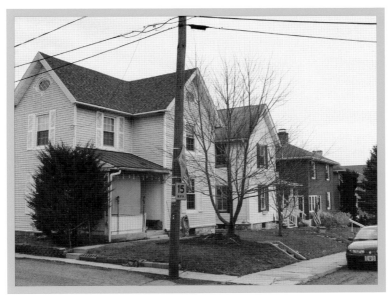

Some of the first homes built by Milton Hershey for his workers were located north of the factory, adjacent to the village of Derry Church. While solid and well-built, they only included two designs. Wishing to avoid the look of a company town, he immediately instructed that future homes be built in a variety of styles with the hope of creating a visually diverse landscape attractive to both workers and their families.

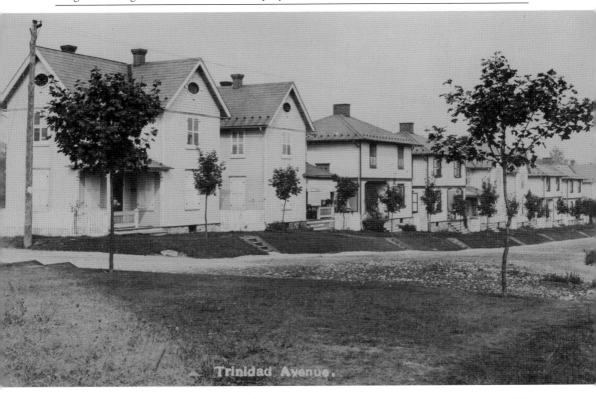

Trinidad Avenue.

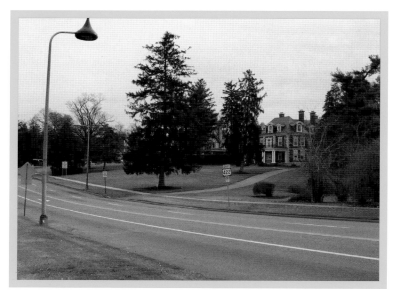

The larger homes built on the east end of Chocolate Avenue, near High Point mansion, were constructed primarily for chocolate company executives. From left to right, the three homes in this image were built for Ezra F. Hershey, William F.R. Murrie, and James B. Leithiser. In contrast to the home of a worker that might cost $2,000 to build, these homes averaged more than $10,000 to construct.

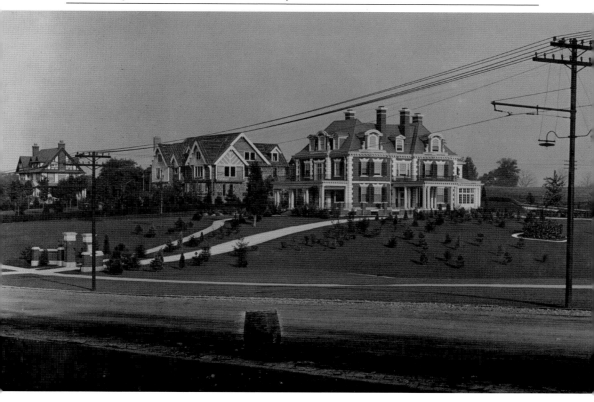

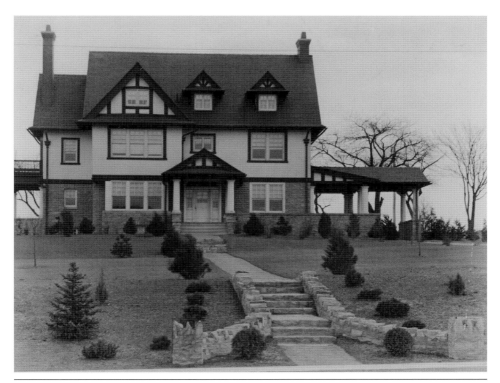

This view of the home of Ezra F. Hershey was taken in 1911. A cousin of Milton Hershey and the only one of his relatives to be employed in the chocolate business, Ezra Hershey served on all the boards of the various Hershey corporate entities and as treasurer of the chocolate company until his retirement in 1948. Located at 278 East Chocolate Avenue, the building has been converted into apartments and is now a Hershey Trust Company rental property.

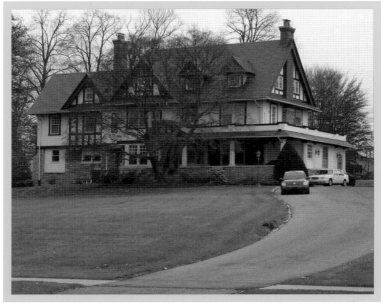

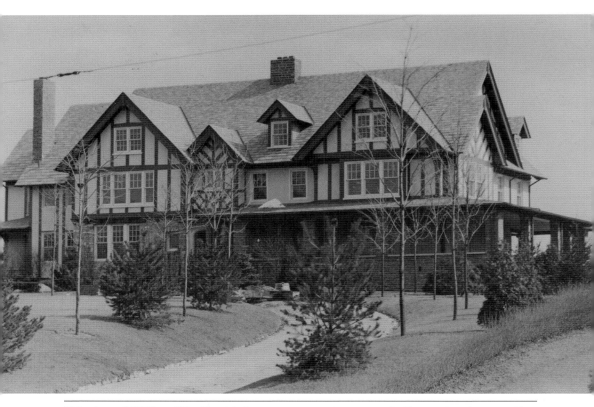

This view of William F.R. Murrie's home was taken in 1911. William Murrie began working for Milton Hershey in 1895 while he was still located in the town of Lancaster. He began as a salesman and became president of the Hershey Chocolate Company in 1908 when the company was incorporated. He continued as president until his retirement in 1947. Located at 256 East Chocolate Avenue, the building has been converted into apartments and is a Hershey Trust Company rental property.

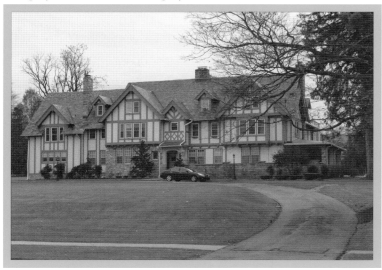

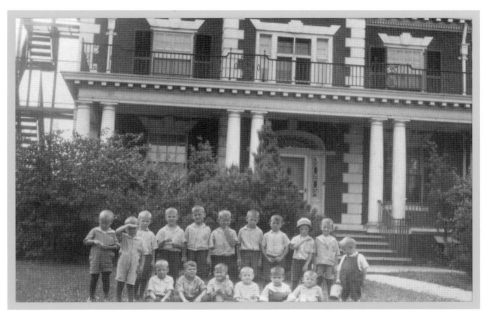

After marrying Lorena Hershey, a cousin of Milton Hershey, James B. Leithiser built this Federal-style home at 238 East Chocolate Avenue for his family. Leithiser served as general manager for the non-chocolate Hershey interests until 1921. During the 1920s, the home was briefly used to house students of the Hershey Industrial School before being converted into three apartments in the 1930s. The structure is now a Hershey Trust Company rental property.

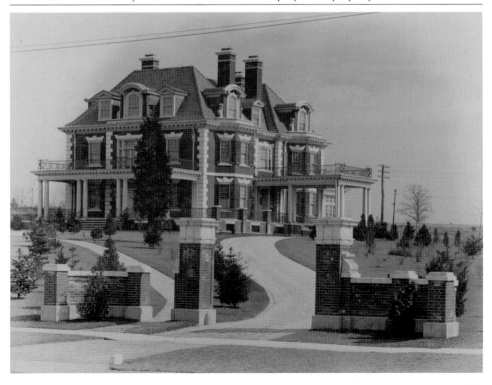

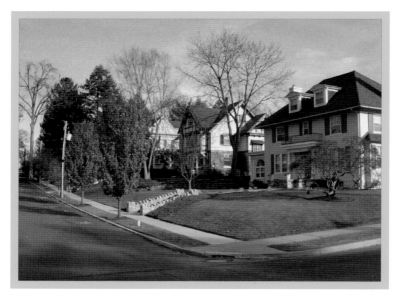

Many of the street names in the town of Hershey echo the names of places where cocoa beans were grown—names like Areba, Bahia, Caracas, Ceylon, Granada, Java, Para, and Trinidad continue to dot the downtown residential landscape. Homes like this along East Granada Avenue continue to be valued as much for their aesthetic value as for the quality of their construction.

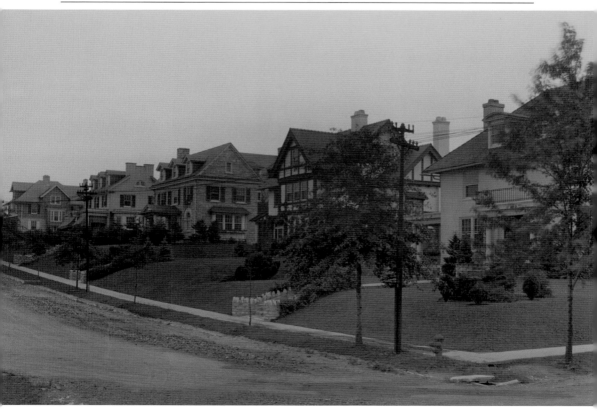

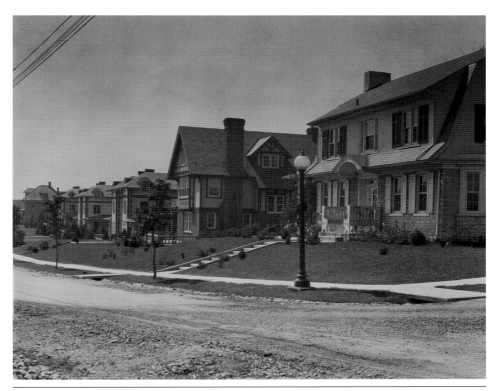

Like all homes in Hershey, these houses at Java and East Caracas Avenues featured sidewalks, setbacks from the street, and street-side lighting. Until the 1960s, Hershey Estates administered all non-chocolate interests in the town, allowing residents to bundle their electric, water, sewer, and telephone bills to one supplier. Though the house on the corner (far right) has been replaced, the rest of the homes on this block still appear much as they did when they were first built.

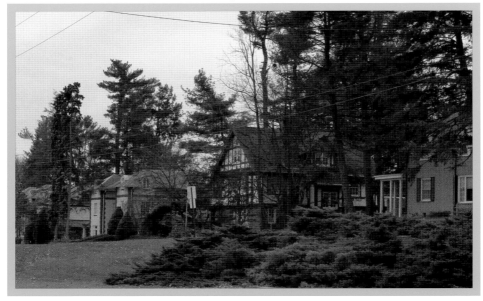

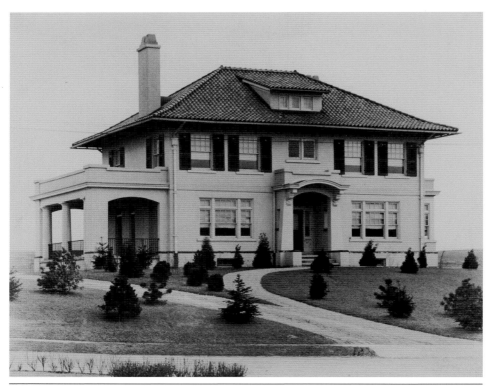

Until 1926, this home at 246 East Caracas Avenue served as the residence of longtime Hershey employee Thomas L. McHeffey. From 1928 through 1929, the residence served as a student home for high school–age students of the Hershey Industrial School. The home then served as the residence of W.A. Hammond, who served as principal of the Junior-Senior High School of the Hershey Industrial School from 1934 until his retirement in 1959. The home remains a private residence.

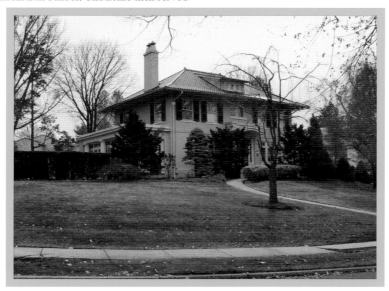

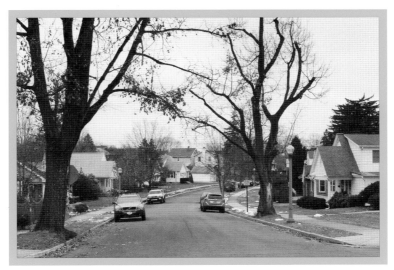

Milton Hershey made sure that the streets around the chocolate factory included a variety of housing options for his workers. Modest homes like these on the first block of Maple Avenue provided easy access to schools as well as recreational and commercial areas. While Hershey's interest in the welfare of his workers and in creating a model community was neither unique nor unprecedented, the town of Hershey became unique because it reflected the beliefs and personality of its creator.

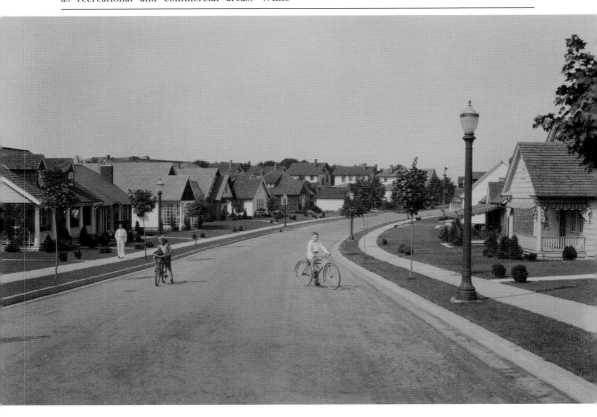

This view of the 100 block of Maple Avenue indicates the variety of sturdy, well-built homes available in Hershey. Milton Hershey established the Hershey Improvement Company to construct roads, homes, and public buildings as well as lay water, sewer, and electric lines. From the start, Hershey encouraged families to buy lots and build their own homes. The quiet tree-lined streets, porches, and front yards encouraged a feeling of security and safety and helped foster a strong sense of community.

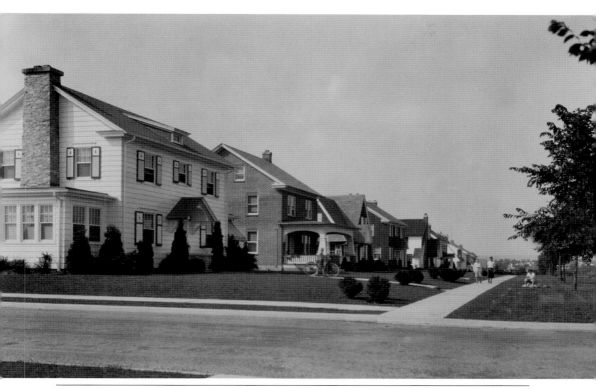

Milton Hershey desired to build a community that was both functional and attractive. He hired renowned landscape architect Oglesby Paul, landscape gardener of Philadelphia's Fairmont Park, to develop a landscape plan for the town. His plan emphasized the planting of trees along streets and flowerbeds in public places. As part of his design, homes along Elm Avenue were characterized by a boulevard-like setting featuring deep setbacks and a wide, tree-lined berm between sidewalk and street.

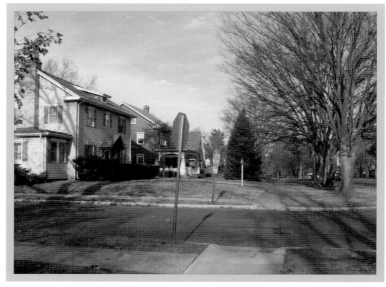

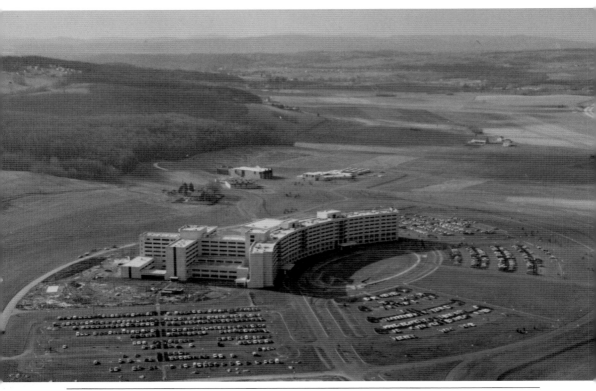

In 1963, the M.S. Hershey Foundation offered $50 million to Pennsylvania State University to establish a medical school in Hershey. With an additional $21.3 million from the US Public Health Service, the university began construction of a medical school, research center, and teaching hospital in 1966. Penn State College of Medicine enrolled its first medical school class in 1967. Penn State Milton S. Hershey Medical Center accepted its first patients in 1970. Today, the medical center includes a free-standing Children's Hospital and Cancer Institute. (Penn State Hershey Medical Center.)

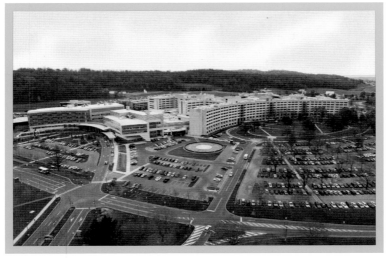

CHAPTER

MILTON HERSHEY SCHOOL

IT WAS KITTY'S IDEA

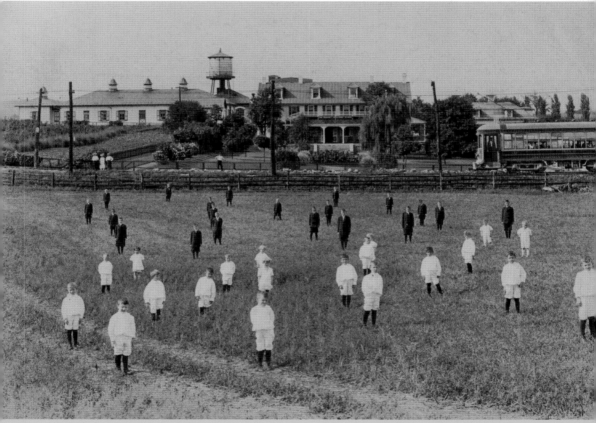

Milton and Catherine "Kitty" Hershey signed the deed of trust establishing their home and school for orphan children on November 15, 1909. When asked, Milton always said the idea for starting what was originally called the Hershey Industrial School belonged to Kitty. When this photograph was taken in 1914, the school had grown to include the 40 boys pictured here.

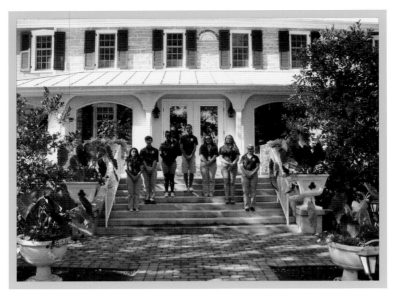

The Homestead served as home and school for the first 10 boys who enrolled in the fall of 1910. An integral part of the school campus, The Homestead provides students with a physical link to the early history of the school and reminds them of the role they play in perpetuating the legacy of the Hersheys. Here, members of the 2014 Student Government Association continue the tradition of posing on the front steps of The Homestead.

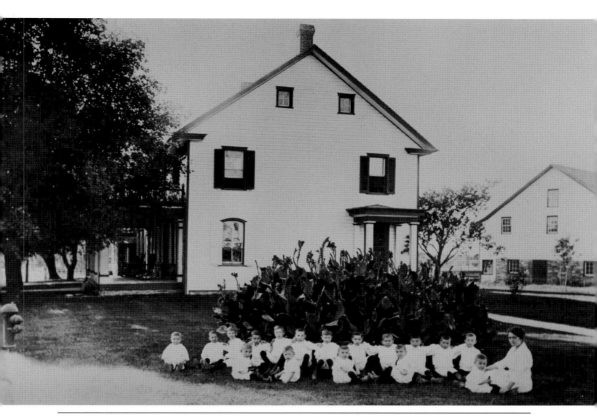

As enrollment increased, Hershey decided to move the youngest boys out of The Homestead and into a nearby farmhome called Kinderhaus, which means "children's house" in German. Originally constructed by a Hershey relative around 1800, Kinderhaus served as a student home from 1912 until 1996. After extensive remodeling and the addition of an archival storage vault and research annex, the facility is now home to the Milton Hershey School Heritage Center and Department of School History.

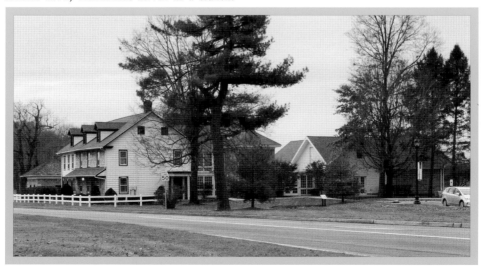

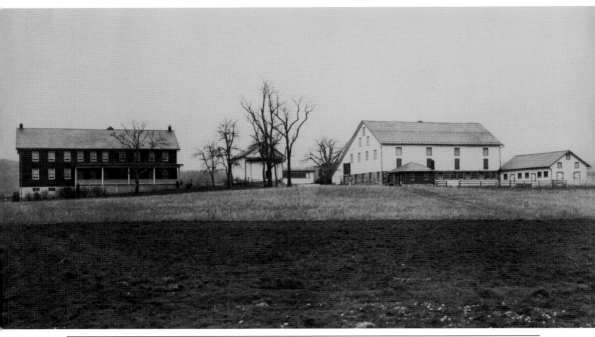

Beginning in 1929, at the urging of Milton Hershey, the school began placing older students on farms. Student farmhome Glendale opened in 1935. In 2000, alumni brothers Richard and Milt Purcell acquired the property, turned it into an educational resource, and renamed it the Dearden House in honor of William Dearden, the only alumnus to head The Hershey Company. In 2004, the school repurchased the property, expanded its mission and facilities, and renamed it the Dearden Alumni Campus.

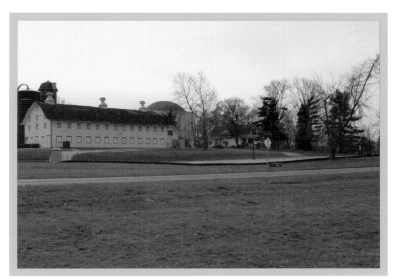

Where existing farmhomes proved impractical to expand, the school constructed large, brick, two-story homes designed to accommodate between 18 and 24 students. Student farmhome Cloverdale (right) opened in 1931. Cloverdale cottage (center) and the adjacent barn originally served as the headquarters for the Hershey Farm company. Cloverdale farmhome was demolished in 2014 to make way for campus enhancements, including construction of a traffic roundabout and a new campus safety and security building. Founders Hall can be seen in the background.

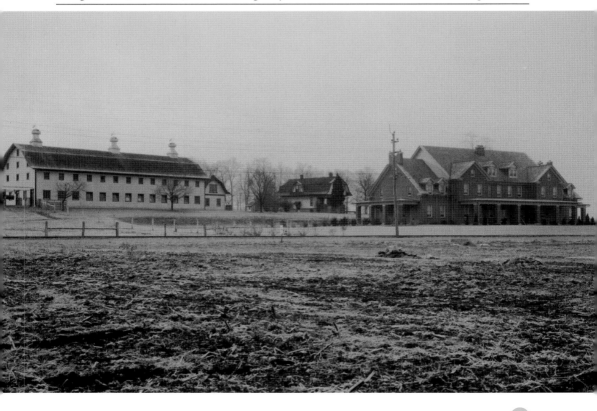

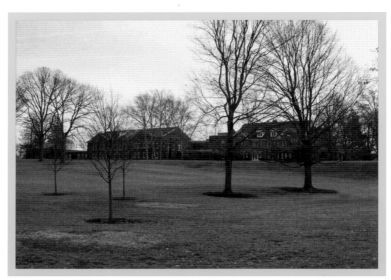

The Hershey Industrial School infirmary (center) opened in 1933. In 1941, the existing Hershey Community Hospital combined with the school infirmary to form the Hershey Hospital. Following the opening of the Penn State Hershey Medical Center in 1970, the hospital closed and became the Health Center for Milton Hershey School. The original building was demolished in 2009 to make way for a new health center. Student farmhome Habana (right) now houses the school's enrollment management and family relations center.

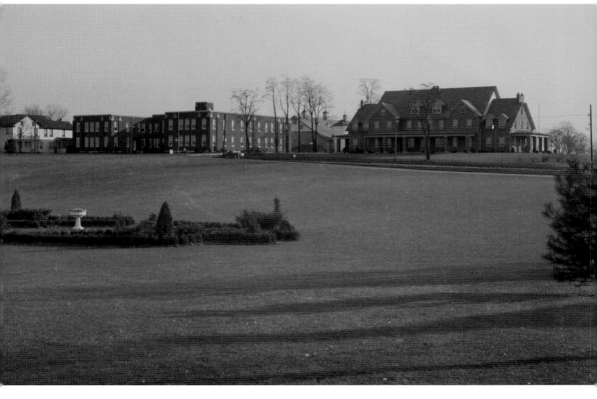

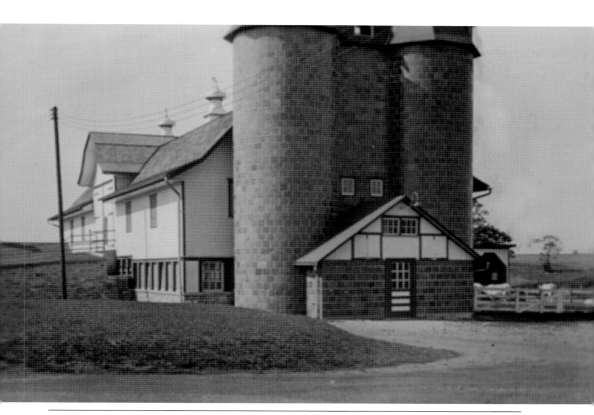

Though students at the school no longer work on farms, many of the barns located adjacent to former student farmhomes on the school campus have been adapted to other uses. The barn of former student home Willow Wood (opened in 1931) serves as the environmental center for the school's Agricultural and Environmental Education program. The lower level of the barn includes classroom space in support of engaging students in experiential, land-based learning.

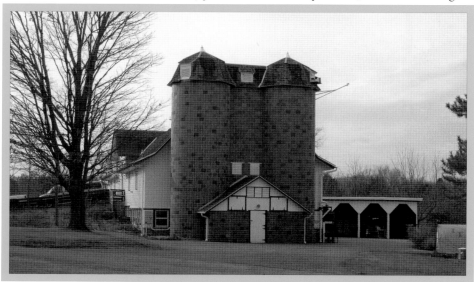

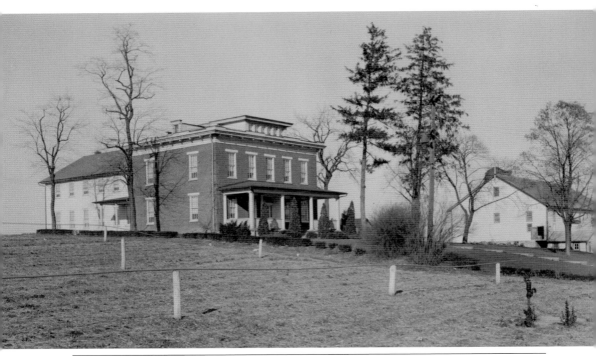

Despite not being used by the school to house students, former student farmhomes in and around Hershey continue to serve the community in a variety of ways. Hershey purchased what became student farmhome Englewood in 1932 from Benjamin Engle. After adding a two-story frame addition, the school used Englewood to house students until 1967. Since 2008, former student farmhome Englewood has served as home to the Cocoa Beanery, a coffee shop and café managed by Hershey Entertainment & Resorts Company. Cocoa Beanery is located adjacent to the Hershey Center for Applied Research and in close proximity to Penn State Hershey Medical Center and Penn State College of Medicine.

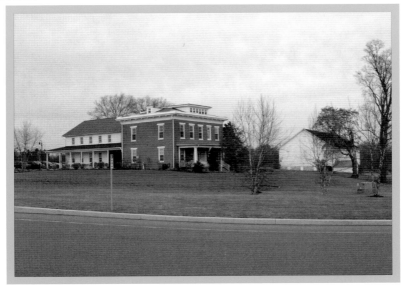

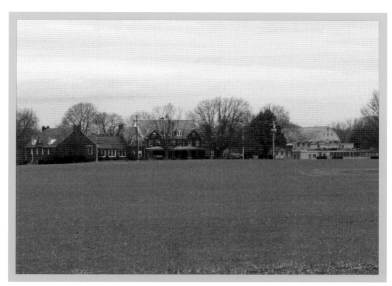

Student farmhome Rolling Green opened in 1936 and housed students until 1968. Since that time, the building has served as headquarters for the Antique Automobile Club of America (AACA), the largest collector car club in the world, and as the AACA Library & Research Center, a repository for materials related to the history of over-the-road transportation. Following a fire in 1949, the original barn was replaced with the current barn, since converted into multi-tenant office space.

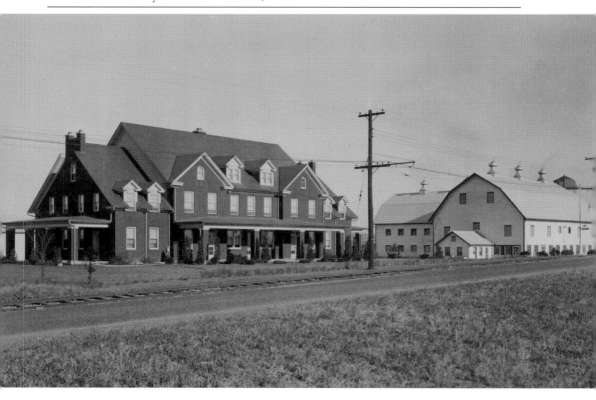

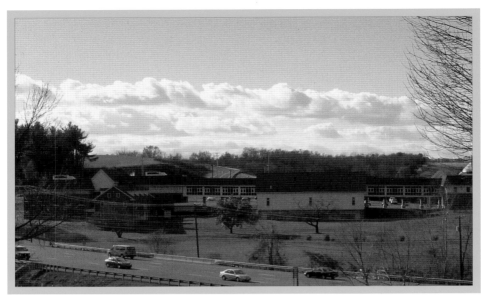

Named for the discovery of a spring while under construction, student farmhome Springdale opened in 1934. Used as a student home until 1990, the property is now part of the Derry Township municipal building complex. The site features two former student homes (Springdale and Union) as well as a timber-frame barn (center). Completed in 2007, the design utilizes an elevated pedestrian walkway to tie the buildings together and provides spaces for administration, meetings, all township offices, and a police station.

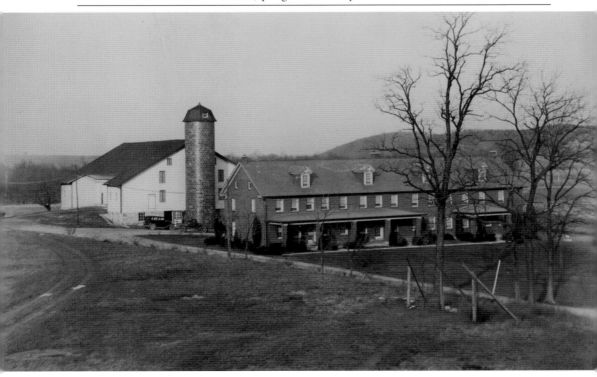

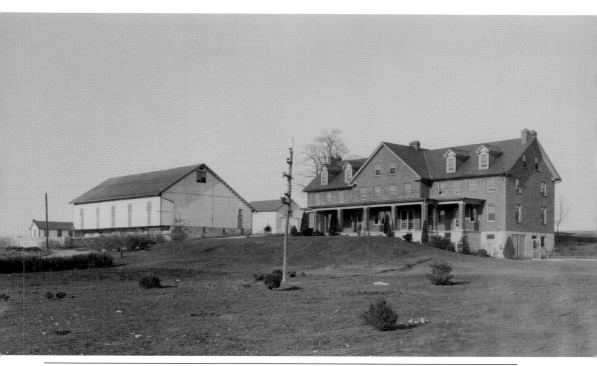

Student farmhome Pinehurst housed Milton Hershey School students from 1931 until 1980. During the 1950s, graduates from the school who attended Hershey Junior College lived at the home. Since being discontinued as a student home, Pinehurst has been used for a variety of purposes. Beginning in 2003, the renovated barn has been home to the Hershey-Derry Township Historical Society museum and library.

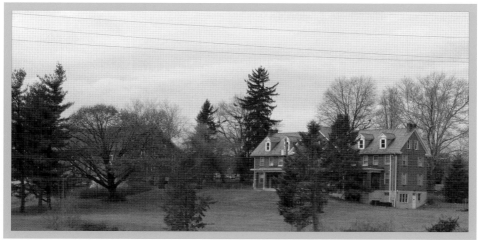

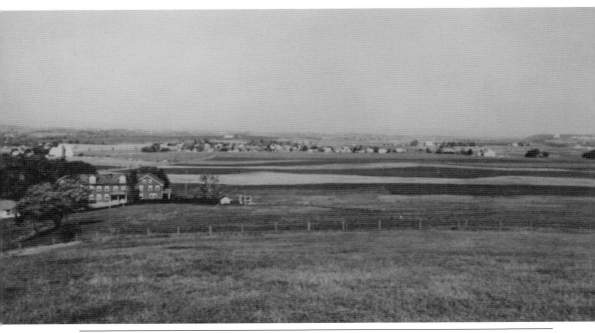

Long Lane served as a Milton Hershey School student farmhome from 1936 until 1964. During construction of the Penn State Hershey Medical Center, the structure served as the first administrative building. As of 2014, the approximately 550-acre medical center and health system includes four hospitals, employs nearly 10,000 staff, and is the only medical facility in Pennsylvania to be accredited as both an adult and a pediatric Level 1 trauma center.

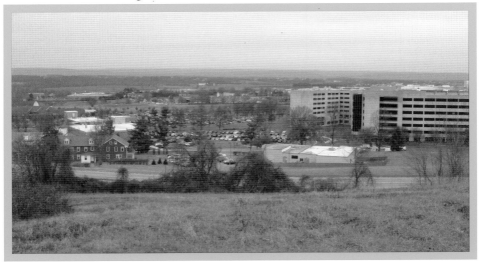

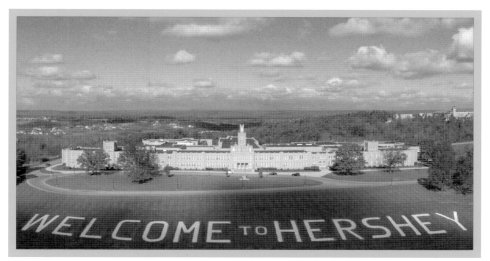

With enrollment on the rise during the Great Depression, the school constructed a junior-senior high school for students in grades six through 12 on a hill overlooking the town of Hershey. Dedication took place on November 15, 1934—25 years after the Hersheys signed the deed of trust. The WELCOME TO HERSHEY sign first appeared in 1960 and was reinstalled in 2007 as part of the building's reconstruction into a state-of-the-art middle school. (Now image courtesy of Edward Fox, Media Boomtown, LLC.)

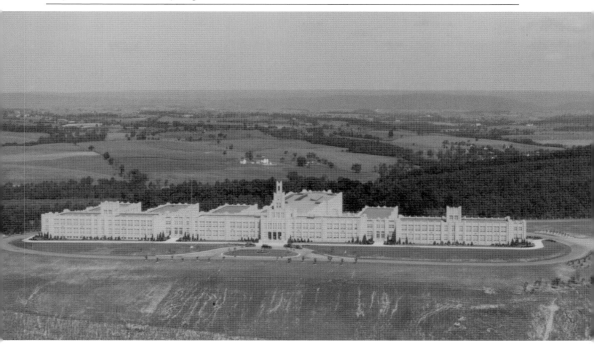

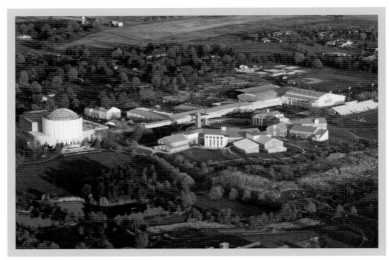

During the 1960s, the school embarked on a building campaign in support of new student programs and support services. By the end of the decade, the school built or renovated over 100 student homes and constructed a new middle school (center) and new administrative center (left with dome). Opened in August 1966, Catherine Hall Middle School also contained an ice-skating rink and Olympic-sized swimming pool. Today, the building is known as Copenhaver Center. (Now image courtesy of James George, All About Hershey, LLC.)

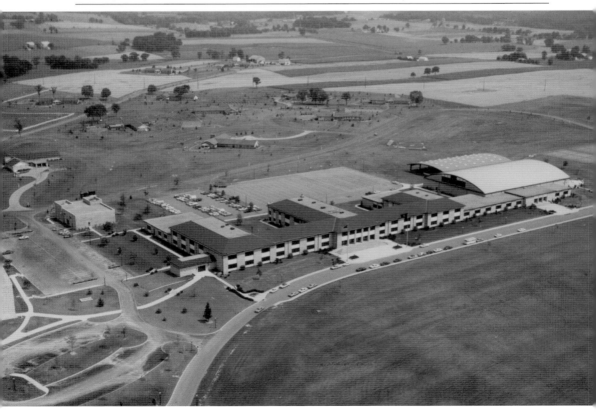

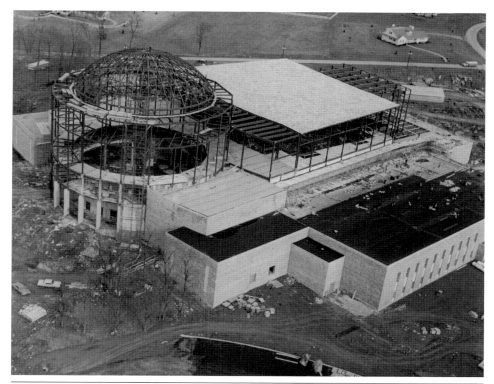

Dedicated on September 13, 1970, as the new administrative center and headquarters for the school, Founders Hall also contains an auditorium/chapel that seats over 2,500 as well as a dining room for students. Meant to be inspirational as well as functional, the building features a rotunda and dome measuring 74 feet from floor to ceiling with an overall height of 137 feet. Construction utilized 16,000 tons of native limestone quarried on campus. (Now image courtesy of James George, All About Hershey, LLC.)

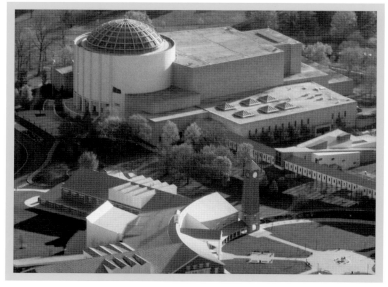

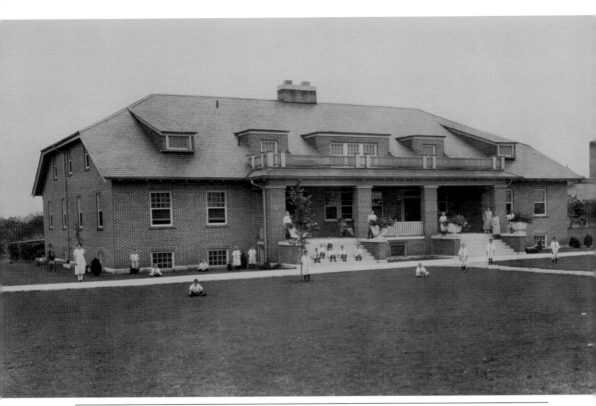

During the 1920s, the school constructed four cottage-style homes near The Homestead. Caaba, the first of these cottages, opened in 1926. Today, these buildings serve as transitional living homes for members of the senior class. Transitional living provides students with an opportunity to live in apartment-style residences in a semi-autonomous fashion with the continued support and care of the residential program. Through experiential learning opportunities, students acquire the necessary practical and social skills that enable life success.

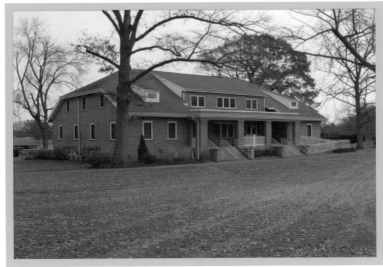

Though the school and the children it serves have changed since 1909, the core mission of preparing students from low-income families to realize their full potential remains unchanged. Fully funded by a trust established by Milton and Catherine Hershey, the school admits students of any race, color, religion, nationality, and ethnic origin. Known as Milton Hershey School since 1951, the school now provides a home and education for more than 2,000 boys and girls. Learn more at www.mhskids.org.

DISCOVER THOUSANDS OF LOCAL HISTORY BOOKS FEATURING MILLIONS OF VINTAGE IMAGES

Arcadia Publishing, the leading local history publisher in the United States, is committed to making history accessible and meaningful through publishing books that celebrate and preserve the heritage of America's people and places.

Find more books like this at
www.arcadiapublishing.com

Search for your hometown history, your old stomping grounds, and even your favorite sports team.